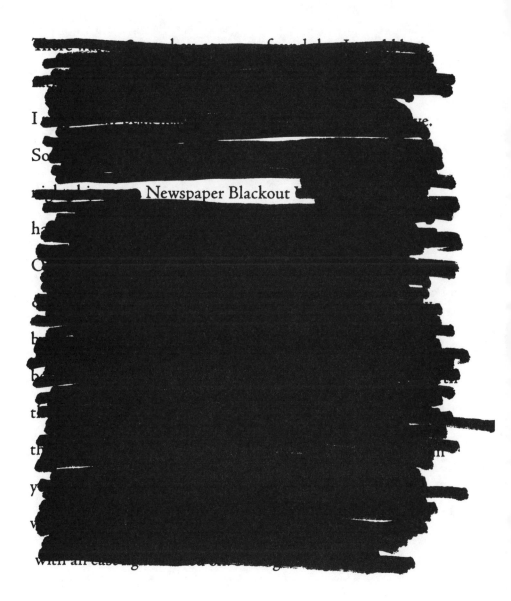

Newspaper Blackout

HARPER PERENNIAL

NEW YORK • LONDON • TORONTO • SYDNEY • NEW DELHI • AUCKLAND

About the Author

AUSTIN KLEON is a writer, cartoonist, and designer. His Newspaper Blackout Poems have been featured on NPR's *Morning Edition*, in Toronto's *National Post*, and all over the Web. He lives in Austin, Texas, with his wife, Meghan. For more information on Austin Kleon and Newspaper Blackout Poems, please visit www.austinkleon.com.

Newspaper Blackout

—Austin Kleon

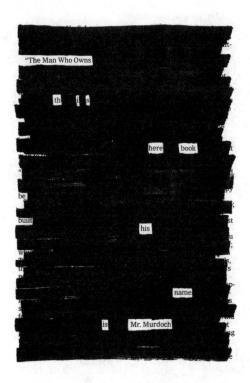

"The Man Who Owns

th i s

here book

be

built

his

w

name

is Mr. Murdoch

HARPER ● PERENNIAL

HarperCollins books may be purchased for educational, business, or sales promotional use. For information please write: Special Markets Department, HarperCollins Publishers, 10 East 53rd Street, New York, NY 10022.

FIRST EDITION

Designed by Justin Dodd

Library of Congress Cataloging-in-Publication Data is available upon request.

ISBN 978-0-06-173297-3

10 11 12 13 14 OV/RRD 10 9 8 7 6 5 4 3 2 1

To my wife, Meghan

Contents

How to Make a Newspaper
Blackout Poem

Newspaper Blackout
Poems Contest Winners

Preface

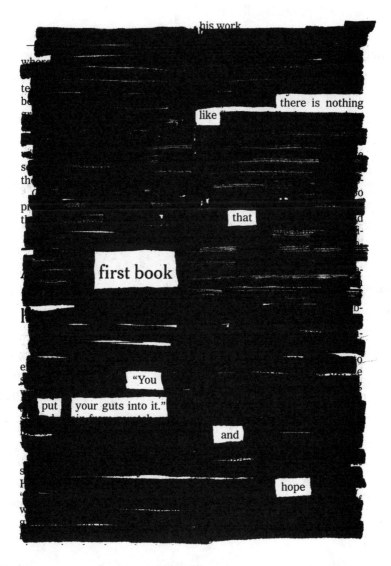

The poems in this book exist thanks to petty crime, writer's block, and the Internet.

Four years ago, my girlfriend, Meg, was working in a crummy neighborhood in Cleveland, Ohio, and some lowlife thief was stealing the daily

newspapers off the office steps. Meg convinced her boss to have the papers delivered to our apartment in a less-crummy neighborhood, where the bandit couldn't get to them. The papers arrived on our doorstep every morning unharmed, and every morning Meg would clip out her industry news to bring with her to work, stacking what remained of the papers in a huge pile beside my desk before heading off.

I was twenty-two at the time, barely out of undergrad, and trying desperately to be a short story writer. Short stories are what they teach you to write in college, and so I tried to write them. But without the structure of academia with homework assignments and writing workshops, I felt lost. I struggled through handbooks of writing exercises. Nothing worked. Each blink of the Microsoft Word cursor taunted me.

Writing wasn't fun anymore.

One day, I looked over at that stack of newspapers left by Meg next to my desk. I might have had no words, but there, right beside me, were *millions* of them.

So, fed up with my short story attempts and failures, I picked up a permanent marker and the Metro section and started blacking out words, leaving a choice few uncovered. I didn't know what I was doing, or why. All I knew was that it was fun to watch those words disappear behind that fat black marker line. It didn't feel like work, it felt like *play*.

That's the entire origin story I have to give you. I've since become suspicious of any artists who claim they knew exactly what they were doing when inspiration struck. The truth is, in the words of Donald Barthelme, art is about "not-knowing." It's when you're bored and frustrated and just looking to have some fun that the good ideas come.

The pile of newspapers turned into pieces of blackened newsprint reeking of marker fumes. They weren't just writing exercises, they were little finished objects. They were short, they made use of the page, they had concentrated language. I'd never wanted to be a poet, but dang, if they weren't poems.

I called them Newspaper Blackout Poems, and I began posting them to my blog.

Time passed. People began to take notice. I'd get e-mails and links from other blogs. The more people showed interest, the more poems I'd post. Much to my surprise, my little poems were creating some big noise around the Internet and in papers around the country. Eventually they made it all the way to a feature story on NPR's *Morning Edition*.

In the four years since I made that first blackout poem to the time of this book's publication, my girlfriend became my wife and we moved miles across the country to Austin, Texas. The following poems were created from June to December 2008. Most were composed on the bus to my day job, during my lunch break in the basement of the building where I work, and on the bus ride home.

What's exciting about the poems is that by *destroying* writing you can *create* new writing. You can take a stranger's random words and pick and choose from them to express your own personal vision.

Writing should be fun. Everyone can do it. I hope this book inspires you to try to create your own blackout poems. They're a fun, constructive way to pass time. They cost next to nothing to make. All you need is yesterday's newspaper and something that marks. I've included a "how-to" section at the end of the book to get you started.

Thanks for reading. If you like what you read, head over to www.austin kleon.com for more.

And if we see each other on the bus with our markers and newspapers, let's be sure to wave hello.

Introduction
A Brief History of Newspaper Blackout

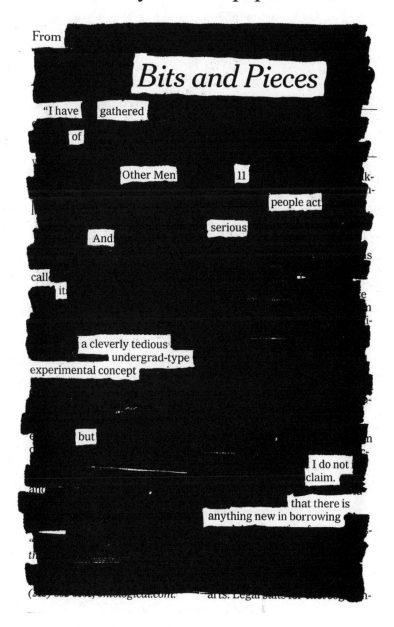

From

Bits and Pieces

"I have gathered of

Other Men 11

people act

And serious

call it

a cleverly tedious undergrad-type experimental concept

but

I do not claim.

that there is anything new in borrowing

When I first put marker to newsprint, I was ignorant of any artistic or poetic precedent.

As a teenager, I'd seen images of John Lennon's declassified FBI files on The Smoking Gun Web site—grainy photocopies of typed agent reports heavily redacted with strokes of black Magic Marker. I printed them out and pasted them in my notebook.

Ten years later, I was posting poems to my blog that looked very much like those files.

I thought I was ripping off the government!

But after a handful of e-mails, blog comments, and message board flames ("1970 called, and Tom Phillips wants his idea back!" "Lame William Burroughs rip-off"), I decided to set out to do a little bit of research as to what might have come before.

As it turns out, there's a 250-year-old history of folks finding poetry in the daily newspaper.

It all begins in the 1760s. Caleb Whitefoord, an English wine merchant, writer, diplomat, and former next-door neighbor of Benjamin Franklin, is living in the country about forty miles outside of London, shut in from bad weather, with only a deck of cards and a few newspapers to amuse himself. He sees no reason why newspapers—a "jumble" of "unconnected occurrences"—can't be as entertaining as a deck of cards, and so, after he reads the tightly columned newspaper in the "old trite vulgar way, i.e. each column by itself downwards" he next reads two columns *across*.

This method of "blind chance" brings about "the strangest connections . . . things so opposite in their nature and qualities, that no man alive would ever have thought of joining them together."

He writes down the best combinations and publishes them under the name "cross-readings." Here are a handful:

This day his Majefty will go in state to
sixteen notorious common prostitutes.

On Tuesday both Houses of Convocation met:
Books shut, nothing done.

Wanted, to take care of an elderly gentlewoman,
An active young man, just come out of the country.

To be lett, and entered on immediately,
A young woman, that will put her hand to any thing

They're a big hit with his peers and fellow writers, one of whom says he "laughed till he cried" while reading them.

Fifty years later, our nation's third president, a man by the name of Thomas Jefferson, decides he digs the teachings of Jesus, but finds all the miracles and supernatural elements of the Gospels a bit ridiculous. So he takes scissors to his King James Bible, cuts out only the parts he likes, and pastes them in a scrapbook. He calls it *The Life and Morals of Jesus of Nazareth.* It later becomes known as *The Jefferson Bible.*

Cut to a surrealist rally in Paris in the 1920s. A Romanian poet named Tristan Tzara proposes to create a poem by pulling words out of a hat. A riot ensues, and the surrealists decide to kick Tzara out of their club. He outlines the method in his "Dada Manifesto on Feeble & Bitter Love":

Take a newspaper. Take some scissors. Choose from this paper an article the length you want to make your poem. Cut out the article. Next carefully cut out each of the words that make up this article and put them all in a bag. Shake gently. Next take out each cutting one after the other. Copy conscientiously in the order in which they left the bag. The poem will resemble you. And there you are—an

infinitely original author of charming sensibility, even though unappreciated by the vulgar herd.

"Poetry," Tzara says, "is for everyone." (Being a quarter Romanian myself, I feel it my duty to note that in Tzara's native language "Dada" means "yes yes.")

The same city of Paris, 1959. A Canadian artist named Brion Gysin is staying in the Beat Hotel. He's mounting paintings on a table covered in newspapers when his utility knife slips and slices through several layers of newsprint. *Writing is fifty years behind painting,* he thinks. He's had an idea for a while that writers need to incorporate painting techniques like collage into their writing in order for the form to advance. He picks up the strips of newsprint and begins composing texts out of the "raw words" into what would become his work, *Minutes to Go.* The texts make him laugh out loud.

His buddy, the writer William Burroughs, gets back from a trip to London, and Gysin shows him the "cut-up" technique. Burroughs goes nuts for it, and begins trying it out for himself. He uses the cut-up technique for many of his novels composed in the sixties, and everywhere proclaims his enthusiasm for cut-ups as a revolutionary way to write.

"Cut-ups are for everyone," he says. "Anybody can make cut-ups."

Burroughs even claimed the cut-ups were a form of time travel: you could predict future events based on the juxtapositions you made.

London, 1966. A twenty-eight-year-old artist named Tom Phillips reads a 1965 interview with William Burroughs in *The Paris Review.* He tries out a few cut-up poems of his own on old magazines he has lying around. He likes the results of the technique, and thinks he can take it a step further. He heads down to a furniture repository stand named *Austin's* (there are no coincidences) and buys the first book he finds for threepence. The book is an 1892 Victorian novel by W. H. Mallock titled *A Human Document.* Phillips begins by blacking out words with pen and ink, leaving only a few words behind, connected by "rivers" of blank page in between the lines of text. He soon starts painting and drawing and collaging over the pages, and

the book turns into a modern illuminated manuscript. By subtracting letters from Mallock's original title, he comes up with the name *A Humument*.

A Humument turns into a forty-year-old and counting work-in-progress. Phillips first publishes it as a book in 1983 and it becomes a cult classic. The fourth edition is published in 2005. The work continues to this day, much of which you can see online at www.humument.com.

San Francisco, 1977. A poet named Ronald Johnson picks an 1892 edition of John Milton's *Paradise Lost* off a bookstore shelf and begins erasing words and lines from the epic poem. He buys more copies of the edition, and after several revisions, publishes his own resulting text, *Radi os* (as with *A Humument*, the title is born by erasing letters from the original). In the book's introduction, as if to fend off any potential criticism about the originality of his poem, he writes, "I composed the holes."

In a later interview, Johnson says regardless of the amusing origins of the project, "You don't tamper with Milton to be funny."

What began as a joke becomes serious.

Beginning in the late 1980s, Crispin Hellion Glover, the actor perhaps best-known for his role as George McFly in the movie *Back to the Future,* adopts Phillips's technique and "treats" old Victorian novels with drawings, photographs, and other collage materials. Most notable of these is his truly bizarre and crazy 1989 book, *Rat Catching,* which is derived from an 1896 book, *Studies in the Art of Rat-Catching.* Glover continues with the technique in several other books, and reads from them in a touring slideshow presentation to this day.

The new millennium is full of activity, as cut-up, collage, DJ, and remix culture enter the mainstream.

2002. French artist Jochen Gerner takes the comic *Tintin in America* and blacks out the speech bubbles into phrases and the colors into abstract symbols. The result is a kind of treatise on American culture, and Gerner calls it *TNT en Amérique.*

2003. The artist Will Ashford adopts a technique very similar to Tom Phillips's and alters the pages of old books into poetry and visual art. He calls his project *Recycled Words*.

2004. The poet Jen Bervin grays out portions of text from Shakespeare's sonnets, and publishes the resulting poems in *Nets*.

2005. The writer and collage artist Graham Rawle publishes the delightful *Woman's World:* a novel written in the conventional manner as a rough draft, and then replaced word-by-word, line-by-line with clippings from 1960s women's magazines. An amazing feat.

2006. The poet Mary Ruefle takes Wite-Out correction fluid to an old book and publishes the tiny book *A Little White Shadow*.

2008. The poet Janet Holmes puts out *The ms of my kin,* an "erasure" of *The Poems of Emily Dickinson*.

Admittedly, this idiosyncratic history looks less like a straight line and more like blips on a radar screen. The figures, separated by decades (and centuries!) are kin in the proximity of their techniques only: they found their own writing by destroying the writing of others. Some have used newspapers and scissors, some have used old Victorian novels and Wite-Out. Some have tried to be funny, some serious. Almost all of them stumbled onto their processes accidentally—they were seeking amusement and diversion from their "normal" routine.

I'm including this history to give credit where credit might be due. I'm sure I've left some creators out: I beg their forgiveness in advance.

I encourage inquisitive readers to seek out the works mentioned here and to Google the authors' names, as well as the terms "found poetry" and "altered books" should they want to seek out more inspiration.

SUGGESTED READING

William Burroughs and Brion Gysin, *The Third Mind*

Paul Collins, "The Lost Symphony," *The Believer* (November 2004)

Papyrius Cursor (pseudonym of Caleb Whitefoord), "Cross Readings from the Newspapers," *The New Foundling Hospital for Wit: Being a Collection of Fugitive Pieces, in Prose and Verse,* edited by John Almon, 1786

Conrad Knickerbocker, "The Art of Fiction No. 36: William S. Burroughs," interview in *The Paris Review* 35 (fall 1965).

Jonathan Lethem, "The Ecstasy of Influence: A Plagiarism," *Harper's* (February 2007)

Tom Phillips, *A Humument*

Graham Rawle, *Woman's World*

Newspaper Blackout Poems

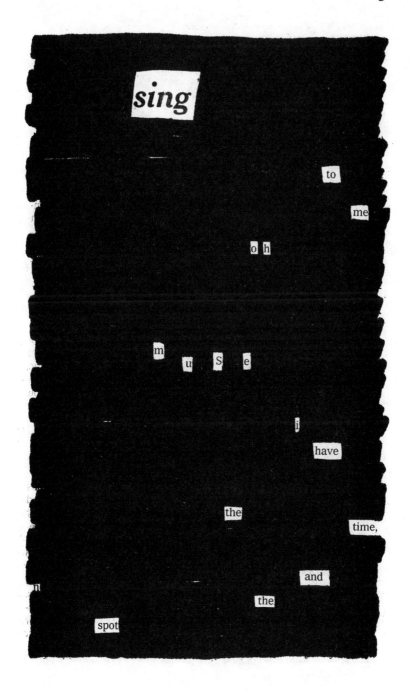

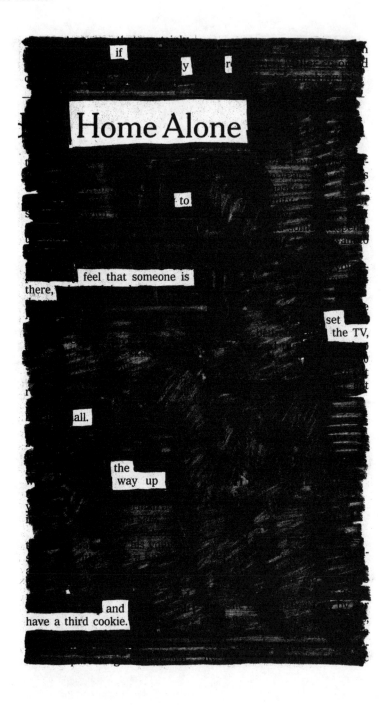

if y r

Home Alone

to

feel that someone is
there,

set
the TV,

all.

the
way up

and
have a third cookie.

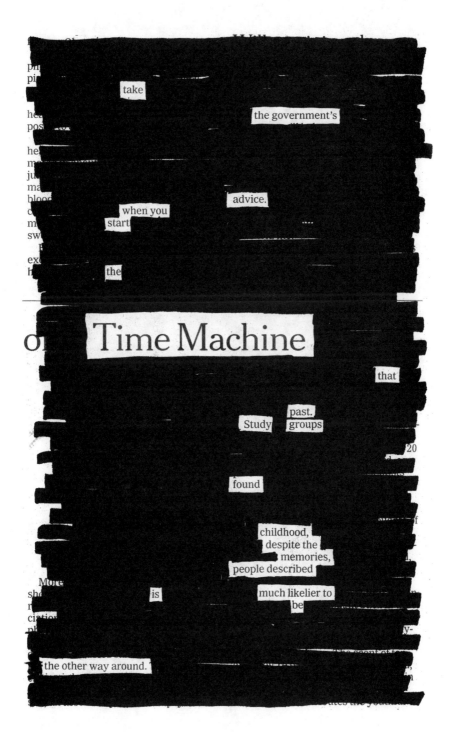

take

the government's

advice.

when you start

the

Time Machine

that

Study past. groups

20

found

childhood, despite the memories, people described

More

is

much likelier to be

the other way around.

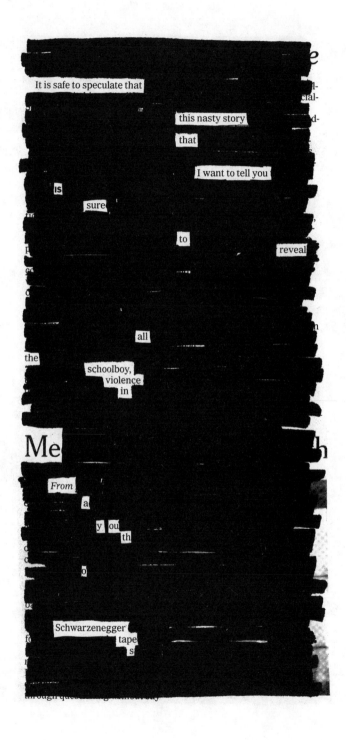

It is safe to speculate that this nasty story that I want to tell you is sure to reveal all the schoolboy, violence in Me From a y ou th o Schwarzenegger tapes

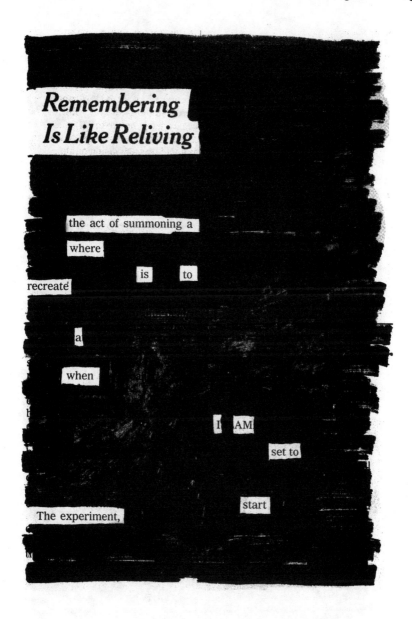

Remembering Is Like Reliving

the act of summoning a

where

is to

recreate

a

when

I AM

set to

start

The experiment,

Gym Class

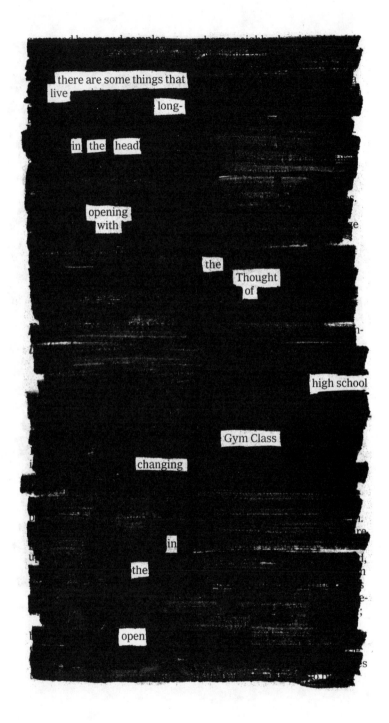

there are some things that
live long-

in the head

opening
with

the
Thought
of

high school

Gym Class

changing

in

the

open

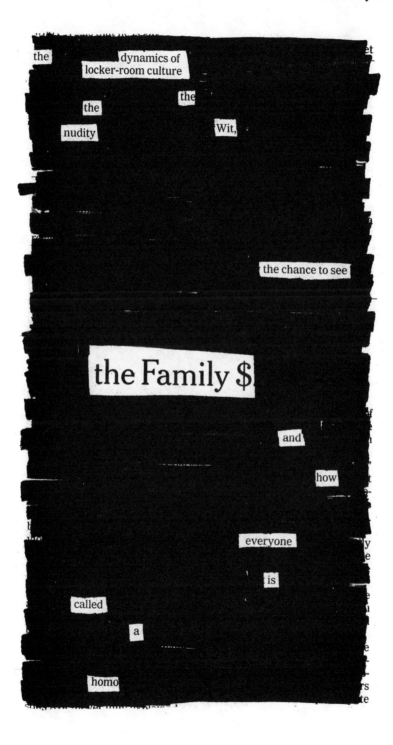

the dynamics of
locker-room culture

the the

nudity Wit,

the chance to see

the Family $

and

how

everyone

is

called

a

homo

9

Tetherball

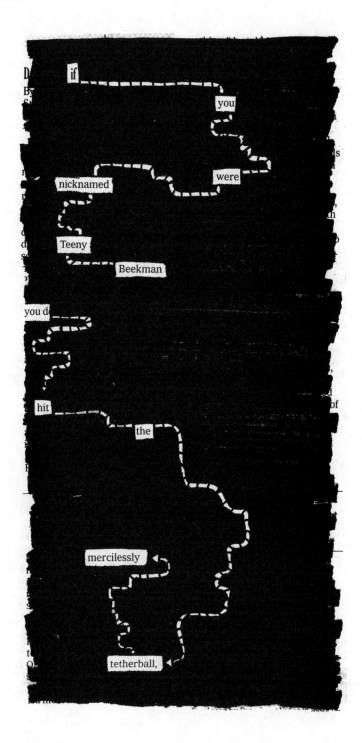

if you were nicknamed Teeny Beekman hit the mercilessly tetherball,

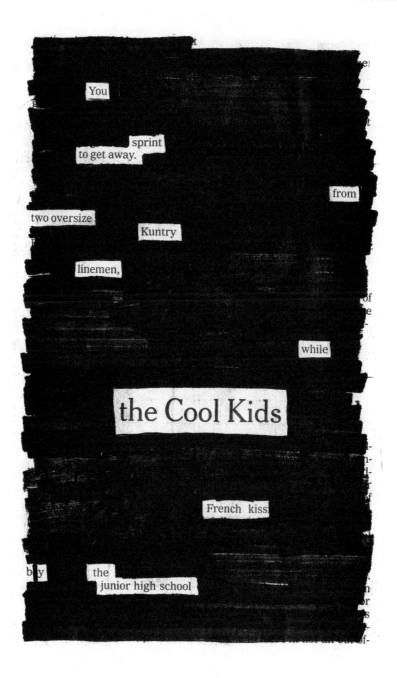

You

sprint
to get away.

from

two oversize

Kuntry

linemen,

while

the Cool Kids

French kiss

boy the
 junior high school

The Bully

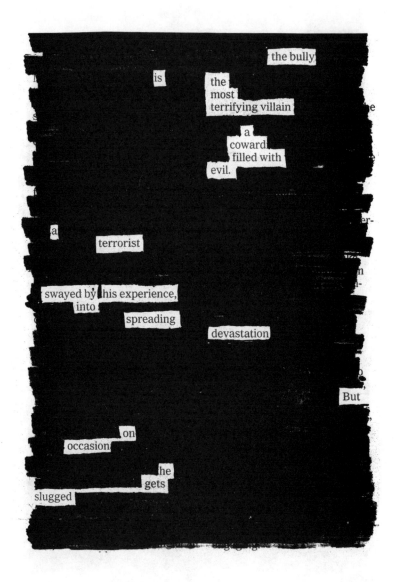

the bully
is the most
terrifying villain
a
coward
filled with
evil.

a
terrorist
swayed by his experience,
into
spreading
devastation
But
on
occasion
he
gets
slugged

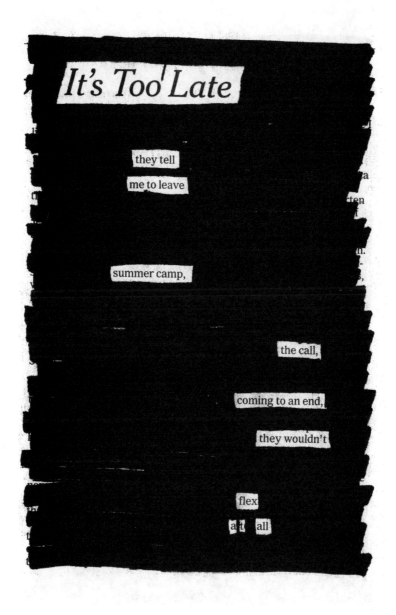

It's Too Late

they tell
me to leave

summer camp,

the call,

coming to an end,

they wouldn't

flex
at all

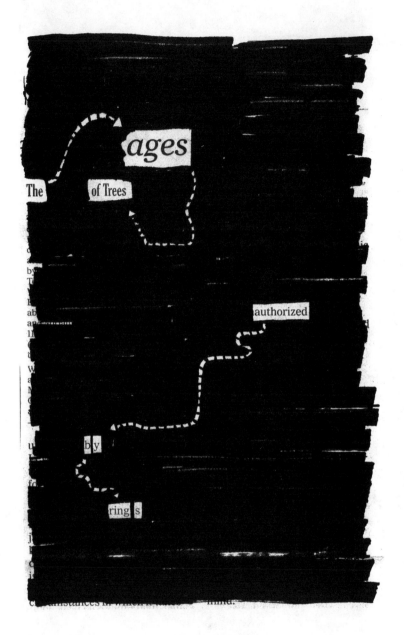

The *ages* of Trees

authorized

by

ring s

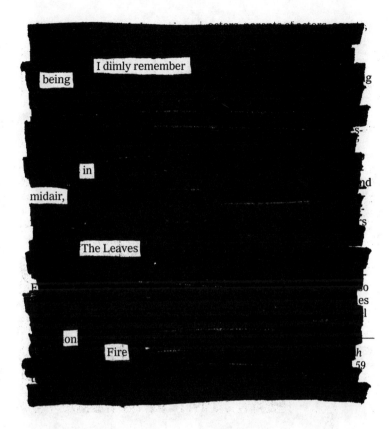

I dimly remember

being

in

midair,

The Leaves

on

Fire

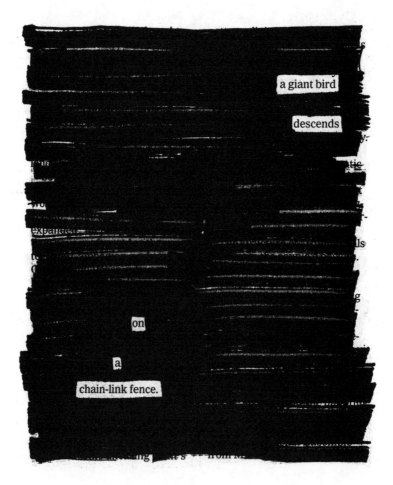

a giant bird

descends

on

a

chain-link fence.

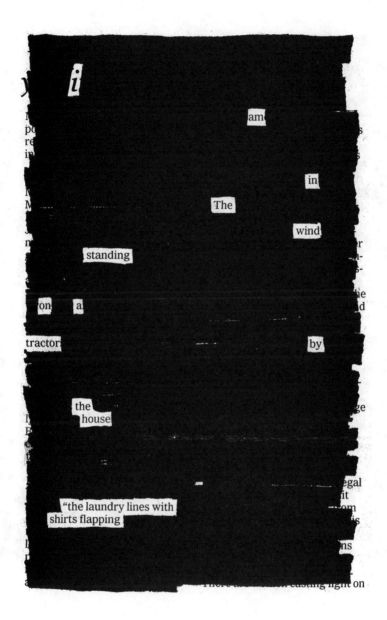

i

am

in

The

wind

standing

on a

tractor by

the
house

"the laundry lines with
shirts flapping

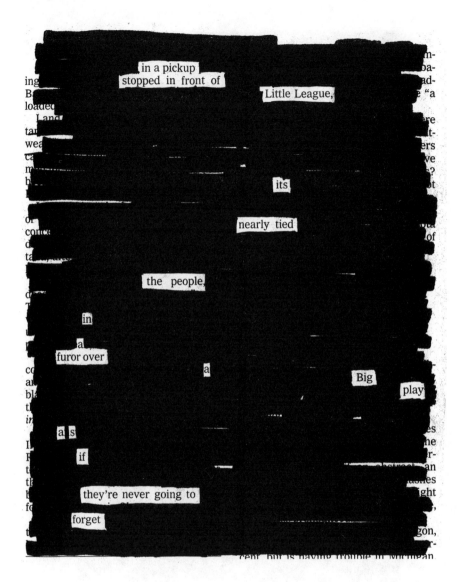

in a pickup
stopped in front of

Little League,

its

nearly tied

the people,

in

a
furor over

a

Big

play

a s

if

they're never going to

forget

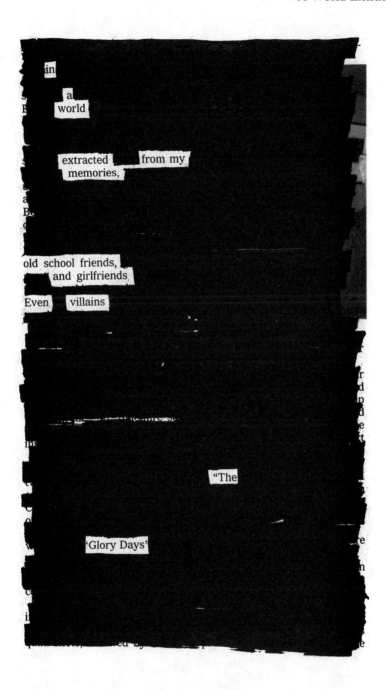

in

a
world

extracted from my
memories,

old school friends,
and girlfriends

Even villains

"The

'Glory Days'

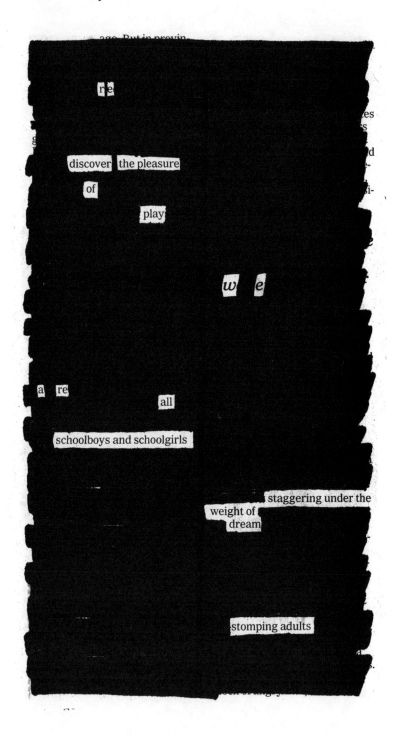

re

discover the pleasure
of
play

w e

a re
all
schoolboys and schoolgirls

staggering under the
weight of
dream

stomping adults

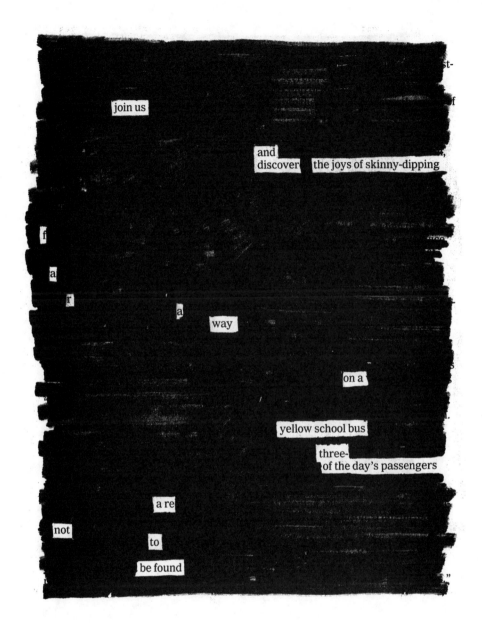

join us

and
discover the joys of skinny-dipping

f

a

r

a

way

on a

yellow school bus

three-
of the day's passengers

a re

not

to

be found

Fireflies

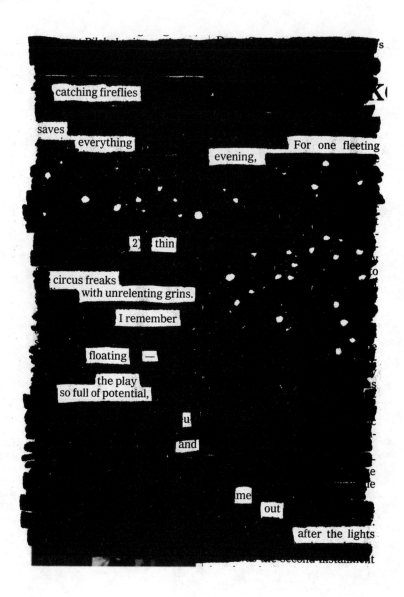

catching fireflies

saves
everything For one fleeting
evening,

2) thin

circus freaks
with unrelenting grins.

I remember

floating —

the play
so full of potential,

u

and

me
out

after the lights

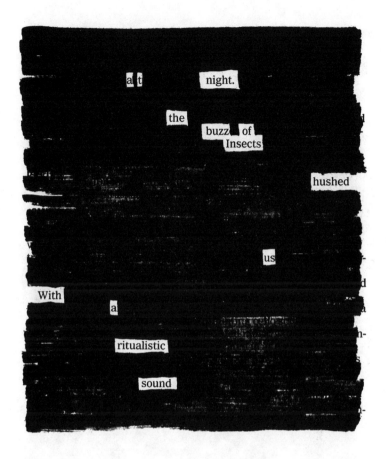

at night.

the

buzz of Insects

hushed

us

With

a

ritualistic

sound

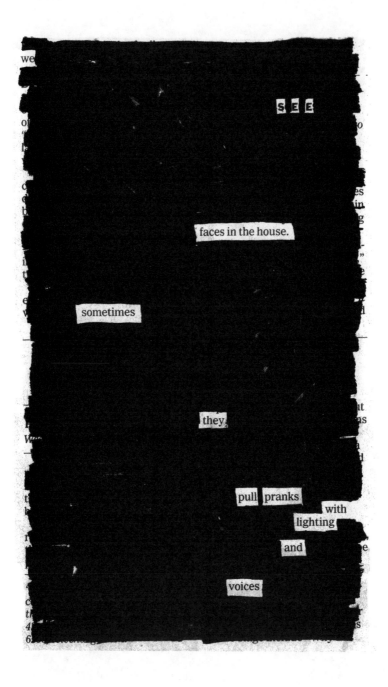

we
SEE
faces in the house.
sometimes
they
pull pranks
with
lighting
and
voices

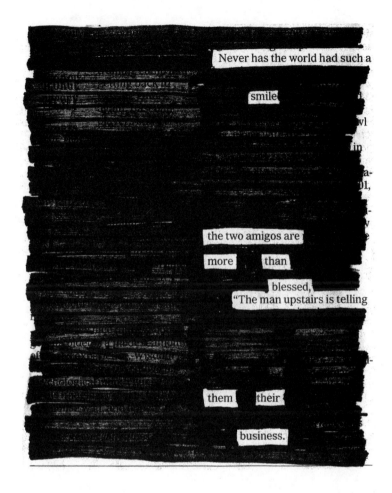

Never has the world had such a

smile

the two amigos are

more than

blessed,
"The man upstairs is telling

them their

business.

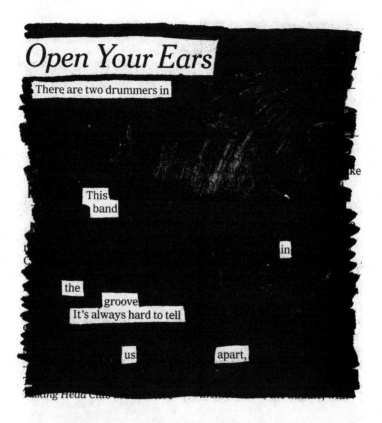

Open Your Ears

There are two drummers in

This
band

in

the
groove
It's always hard to tell

us apart,

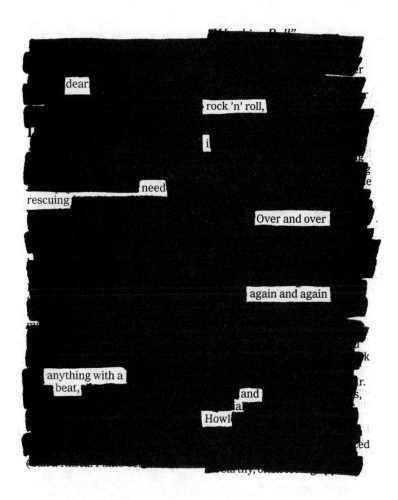

dear
rock 'n' roll,
i
need
rescuing
Over and over
again and again
anything with a
beat,
and
Howl

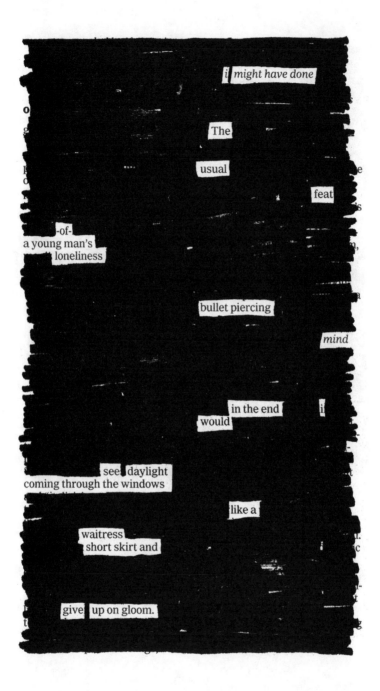

i might have done
The
usual
feat
-of-
a young man's
loneliness
bullet piercing
mind
in the end i
would
see daylight
coming through the windows
like a
waitress
short skirt and
give up on gloom.

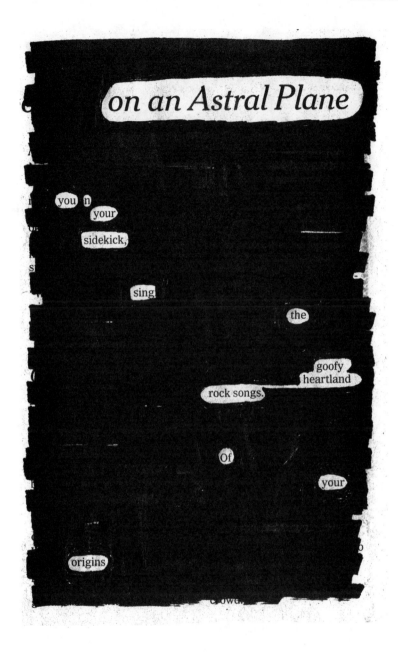

on an Astral Plane

you in your sidekick, sing the goofy heartland rock songs. Of your origins

Children Play

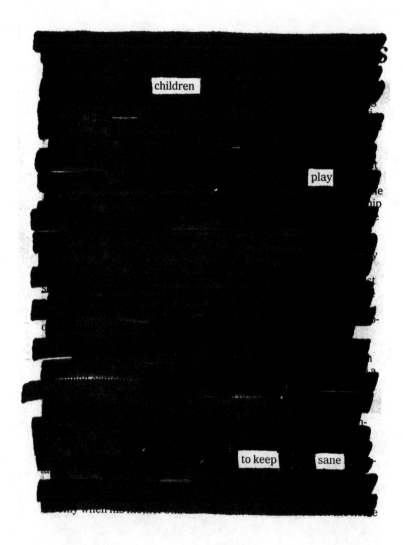

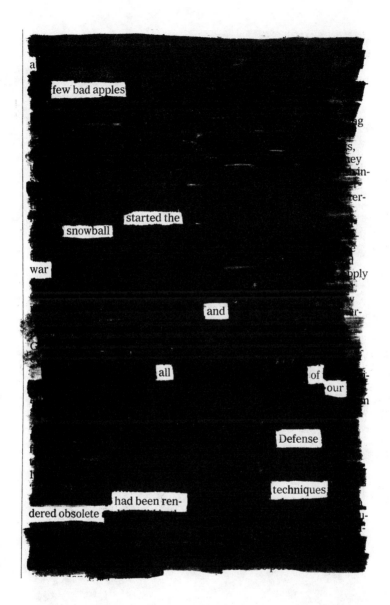

few bad apples

started the

snowball

war

and

all

of

our

Defense

techniques

had been ren-

dered obsolete

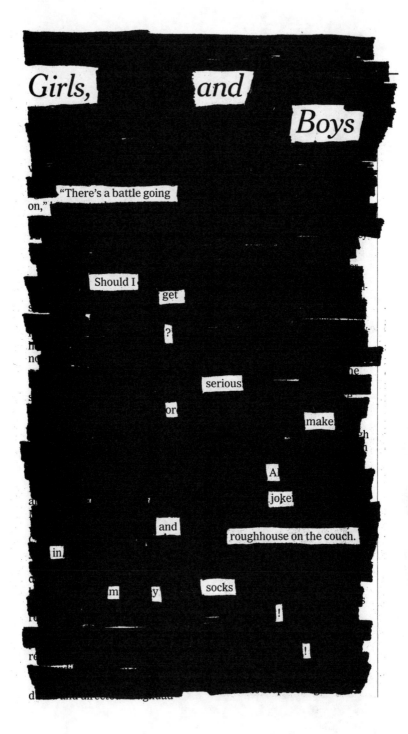

Girls, *and*

Boys

"There's a battle going
on,"

Should I
get

?

serious

or

make

A
joke

and
roughhouse on the couch.

in

m y socks

!

!

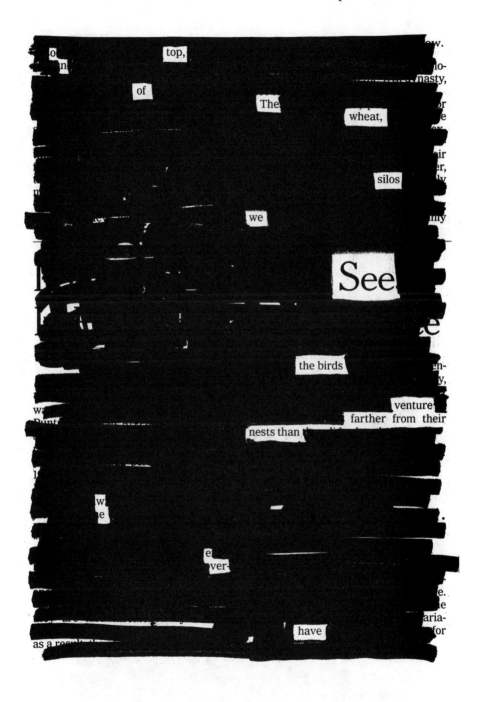

on
top,

of

The
wheat,

silos

we

See

the birds

venture
farther from their
nests than

we

e
ver-

have

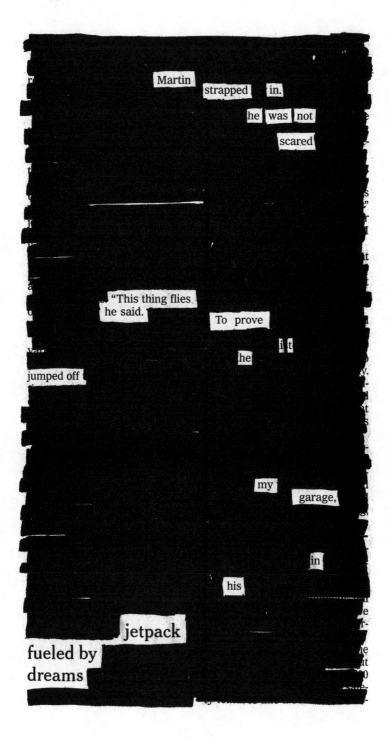

Martin strapped in.
he was not
scared

"This thing flies
he said.
To prove
it
he
jumped off

my
garage,

in

his

jetpack
fueled by
dreams

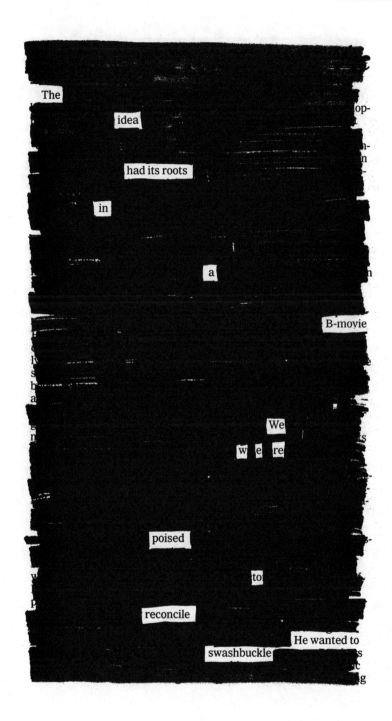

The

idea

had its roots

in

a

B-movie

We

w e re

poised

to

reconcile

He wanted to
swashbuckle

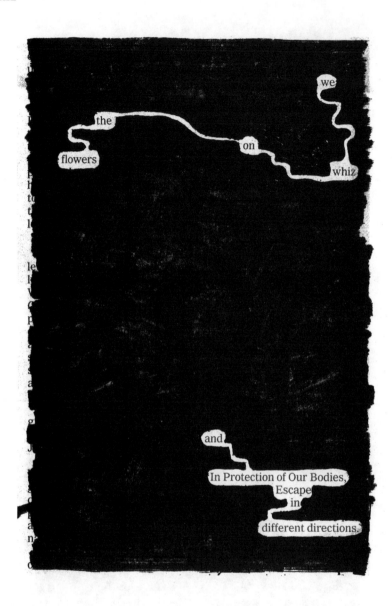

the
we
flowers
on
whiz

and

In Protection of Our Bodies,
Escape
in
different directions.

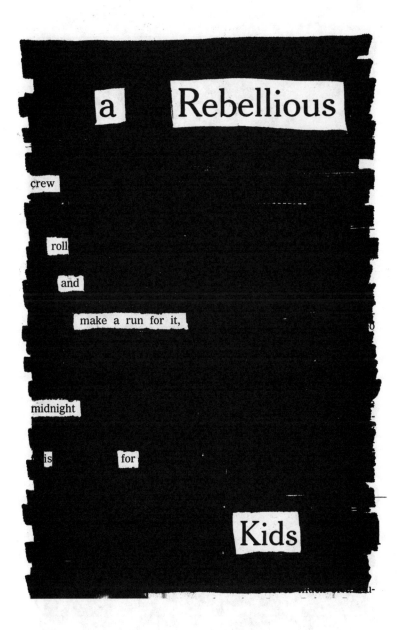

a Rebellious

crew

roll

and

make a run for it,

midnight

is for

Kids

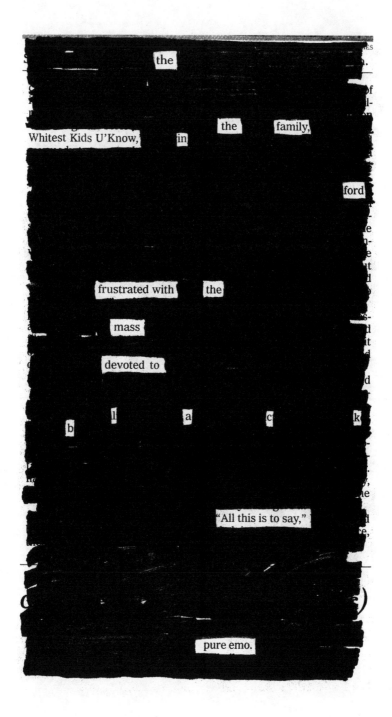

the

Whitest Kids U'Know, in the family,

ford

frustrated with the

mass

devoted to

b l a c k

"All this is to say,"

pure emo.

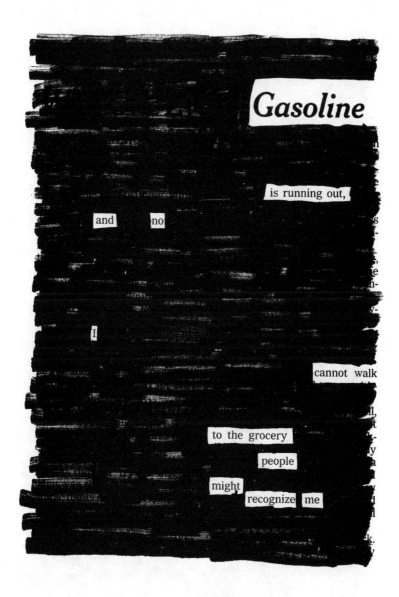

Gasoline

is running out,

and no

I

cannot walk

to the grocery

people

might recognize me

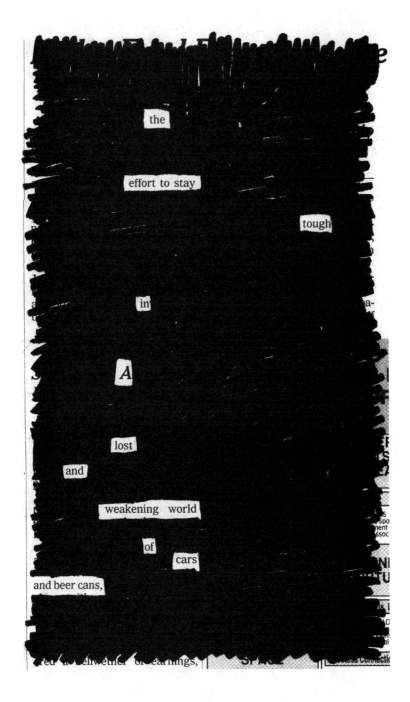

the

effort to stay

tough

in

A

lost

and

weakening world

of

cars

and beer cans,

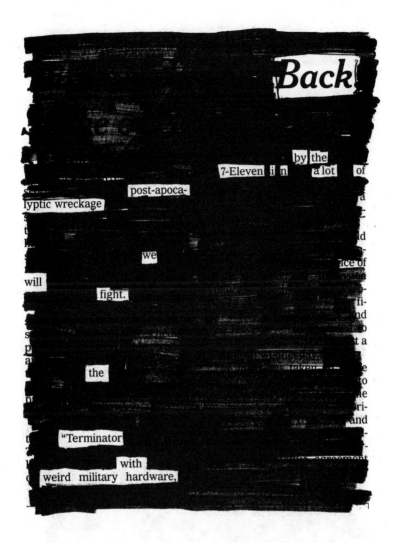

Back

7-Eleven in by the a lot of

post-apoca-

lyptic wreckage

we

will

fight.

the

"Terminator

with

weird military hardware,

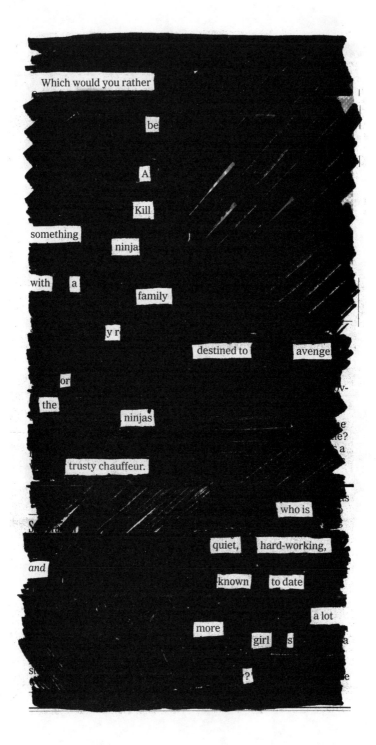

Which would you rather

be

A

Kill

something

ninja

with a

family

y r

destined to avenge

or

the

ninjas

trusty chauffeur.

who is

quiet, hard-working,

and

known to date

a lot

more

girl s

?

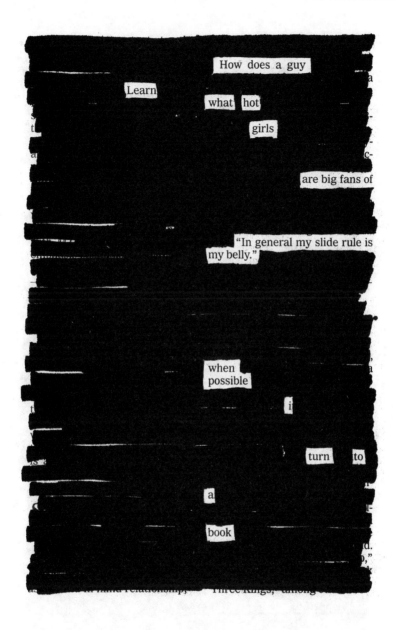

How does a guy

Learn

what hot

girls

are big fans of

"In general my slide rule is my belly."

when
possible

i

turn to

a

book

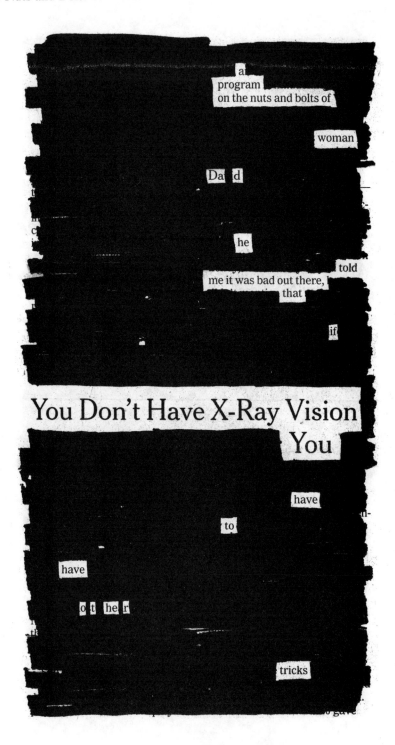

a
program
on the nuts and bolts of

woman

Dad

he

told
me it was bad out there, that

if

You Don't Have X-Ray Vision You

have

to

have

other

tricks

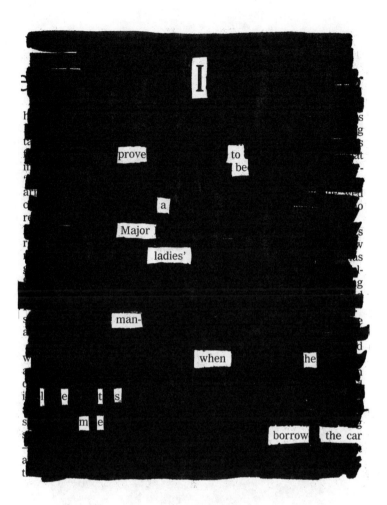

I

prove to be

a

Major

ladies'

man-

when he

l e t s

m e

borrow the car

The Date

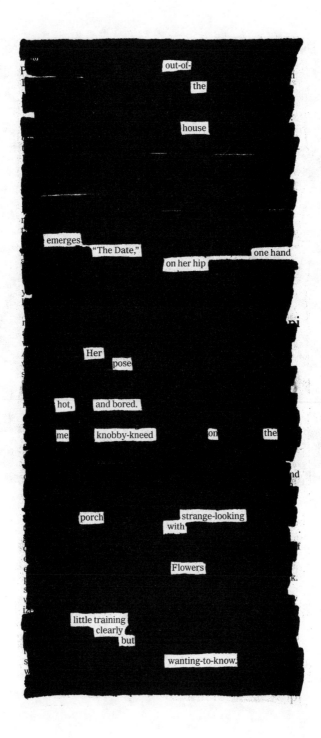

out-of-

the

house

emerges "The Date," one hand

on her hip

Her pose

hot, and bored.

me knobby-kneed on the

porch strange-looking
with

Flowers

little training
clearly
but

wanting-to-know.

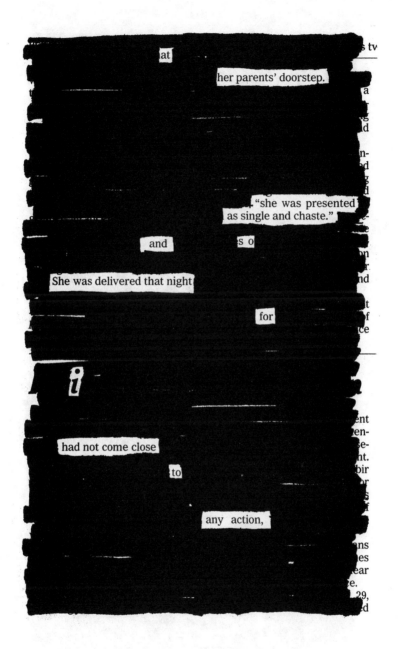

at

her parents' doorstep.

. "she was presented
as single and chaste."

and s o

She was delivered that night

for

had not come close

to

any action,

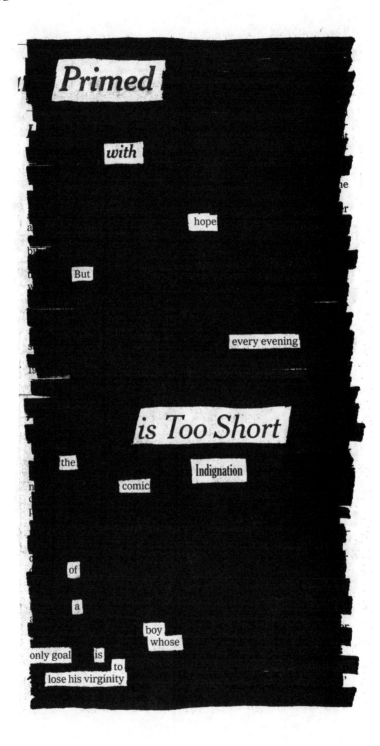

Primed

with

hope

But

every evening

is Too Short

the

Indignation

comic

of

a

boy whose

only goal is to
lose his virginity

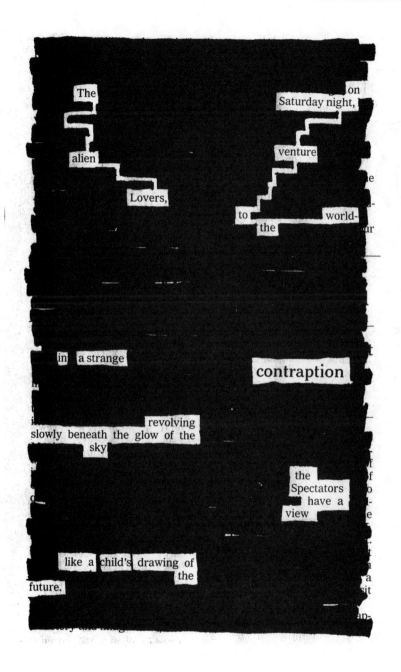

The

on

Saturday night,

alien

venture

Lovers,

to

the

world-

in a strange

contraption

revolving
slowly beneath the glow of the
sky

the
Spectators
have a
view

like a child's drawing of
the

future.

49

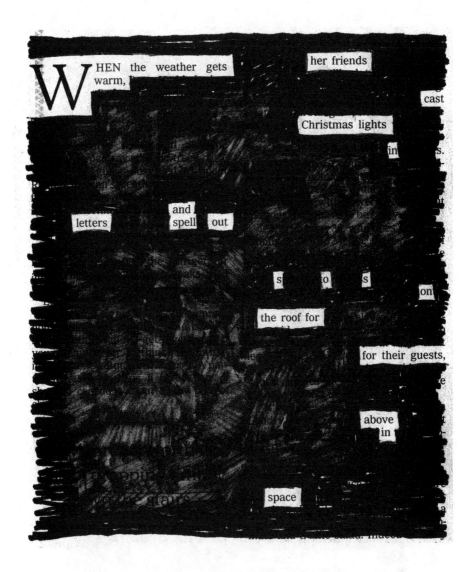

When the weather gets warm,
her friends
cast
Christmas lights
in
letters
and spell out
s to s on
the roof for
for their guests,
above
in
space

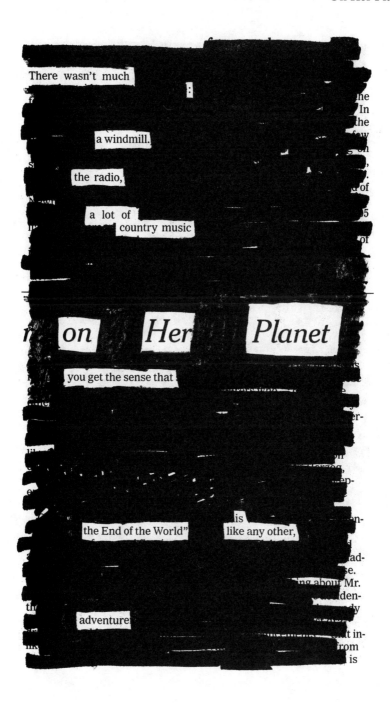

There wasn't much

a windmill.

the radio,

a lot of
country music

on *Her* *Planet*

you get the sense that

the End of the World" is
like any other,

adventure

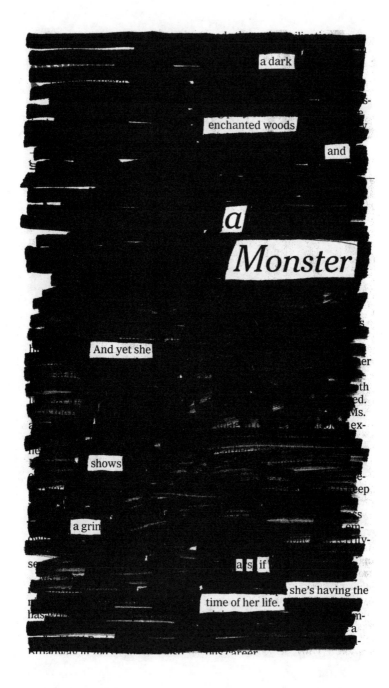

a dark

enchanted woods

and

a

Monster

And yet she

shows

a grin

a s if

she's having the
time of her life.

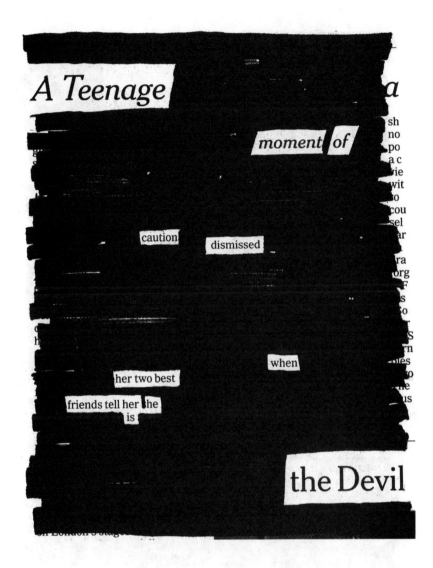

A Teenage

moment of

caution dismissed

when

her two best

friends tell her she
is

the Devil

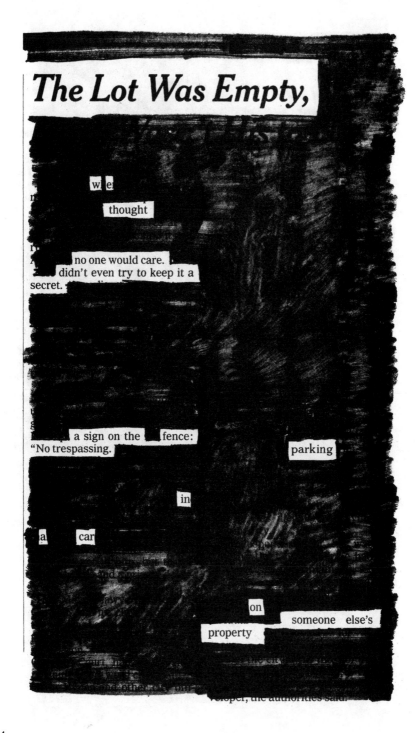

The Lot Was Empty,

when

thought

no one would care.
didn't even try to keep it a
secret.

a sign on the fence:
"No trespassing.

parking

in

a car

on

someone else's

property

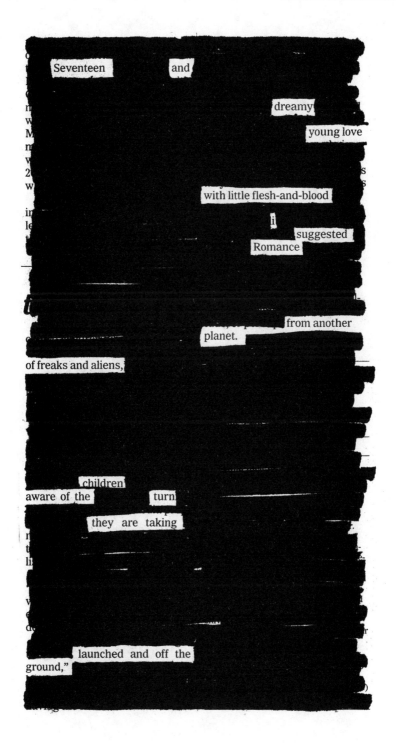

Seventeen and

dreamy

young love

with little flesh-and-blood

i

suggested

Romance

from another

planet.

of freaks and aliens,

children

aware of the turn

they are taking

launched and off the

ground,"

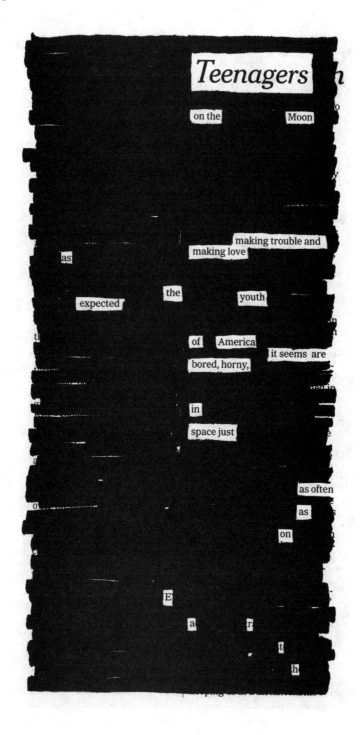

Teenagers

on the Moon

making trouble and
making love

as

expected the youth

of America
bored, horny, it seems are

in

space just

as often

as

on

E

a r

t

h

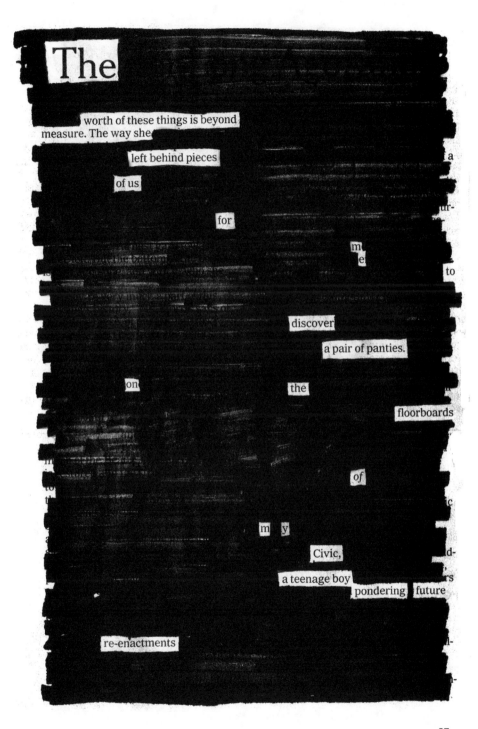

The

worth of these things is beyond
measure. The way she

left behind pieces

of us

for

m
e

to

discover

a pair of panties.

on

the

floorboards

of

m y

Civic,

a teenage boy

pondering future

re-enactments

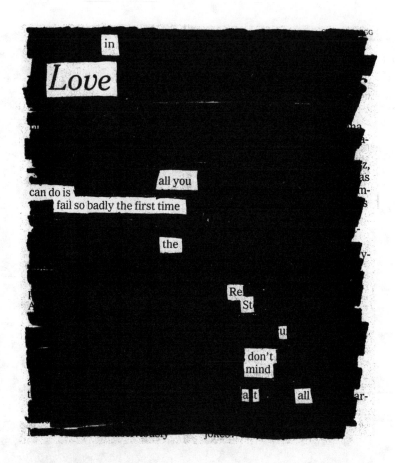

in

Love

all you
can do is
fail so badly the first time

the

Re
St

u

don't
mind

a t all

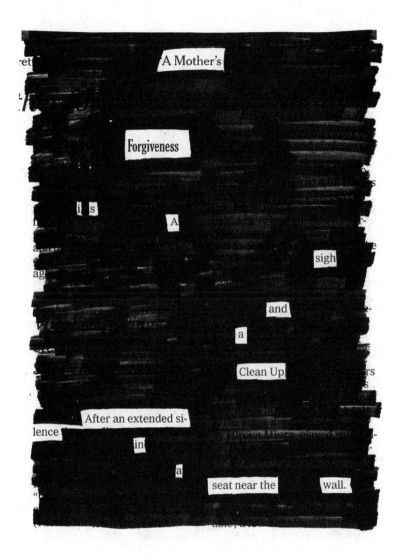

A Mother's

Forgiveness

is A

sigh

and

a

Clean Up

After an extended si-
lence

in

a

seat near the wall.

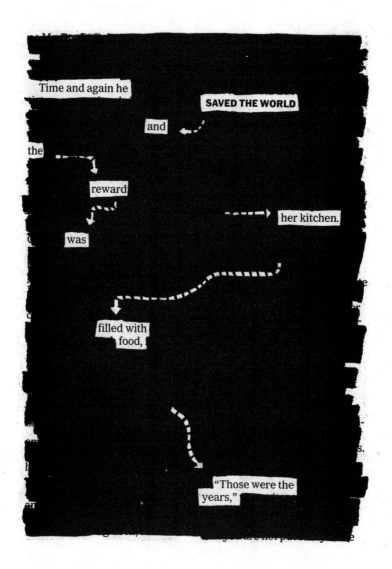

Time and again he SAVED THE WORLD and the reward was her kitchen. filled with food, "Those were the years,"

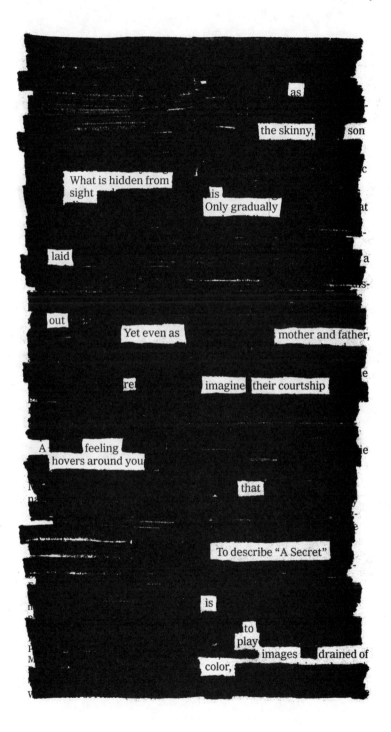

as

the skinny, son

What is hidden from
sight

is
Only gradually

laid

out

Yet even as mother and father,

re imagine their courtship

A feeling
hovers around you

that

To describe "A Secret"

is

to
play
images drained of
color,

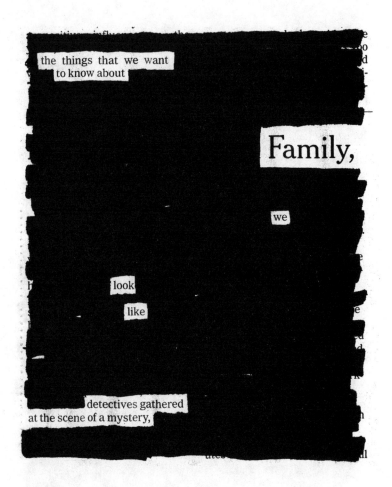

the things that we want
to know about

Family,

we

look

like

detectives gathered
at the scene of a mystery,

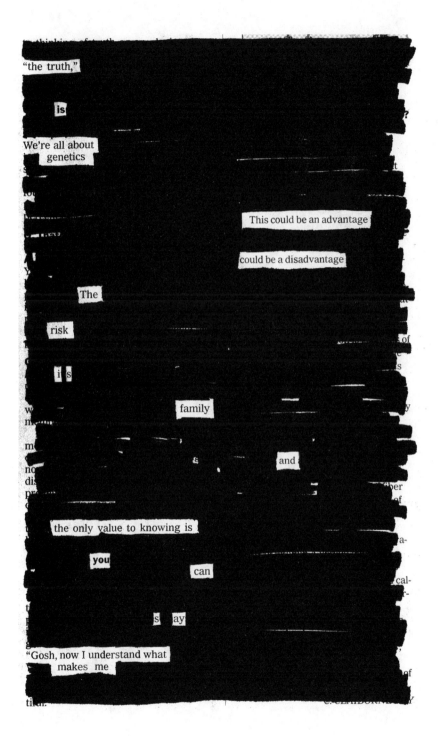

"the truth,"

is

We're all about
genetics

This could be an advantage

could be a disadvantage

The

risk

i s

family

and

the only value to knowing is

you

can

s ay

"Gosh, now I understand what
makes me

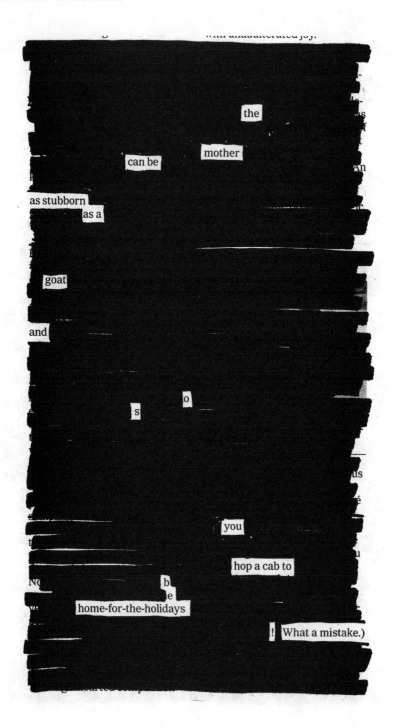

the

mother

can be

as stubborn
as a

goat

and

s o

you

hop a cab to

b
e
home-for-the-holidays

! What a mistake.)

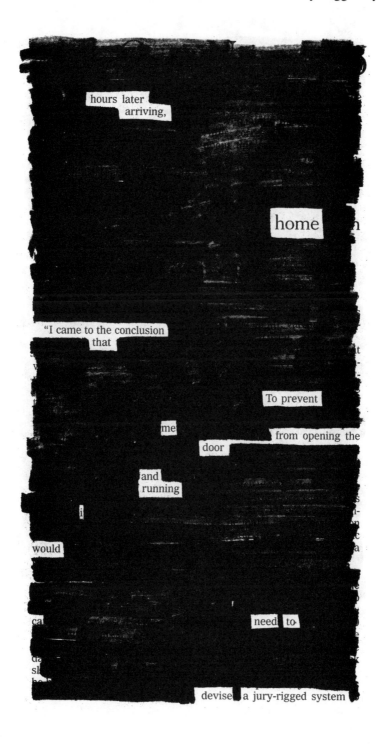

hours later arriving,

home

"I came to the conclusion that

To prevent

me

from opening the

door

and running

i

would

ca

need to

devise a jury-rigged system

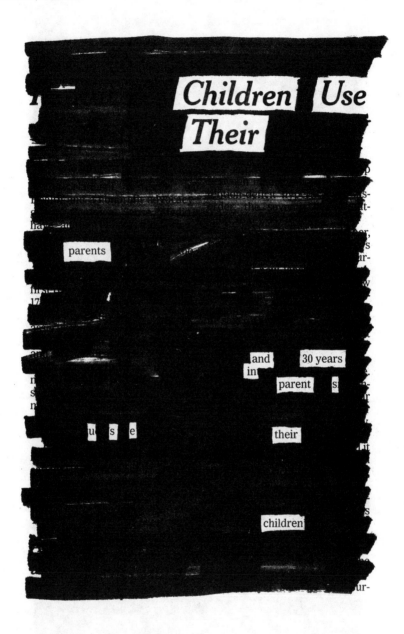

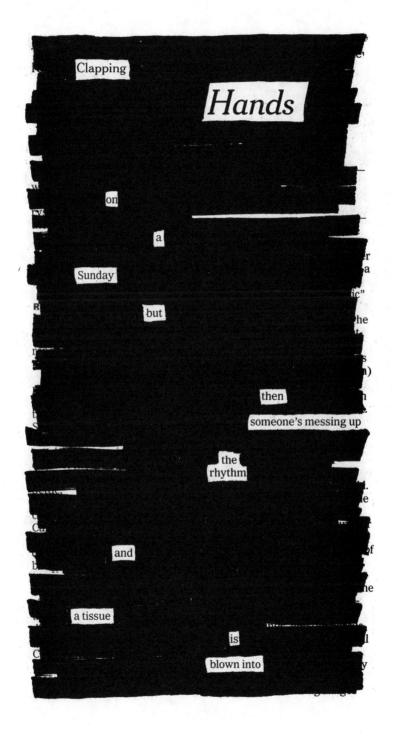

Clapping *Hands*

on

a

Sunday

but

then

someone's messing up

the
rhythm

and

a tissue

is

blown into

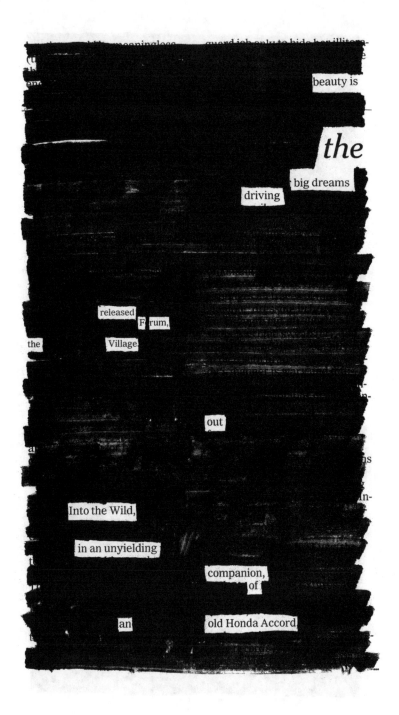

beauty is

the

big dreams

driving

released Forum,

Village.

the

out

Into the Wild,

in an unyielding

companion,
of

an old Honda Accord.

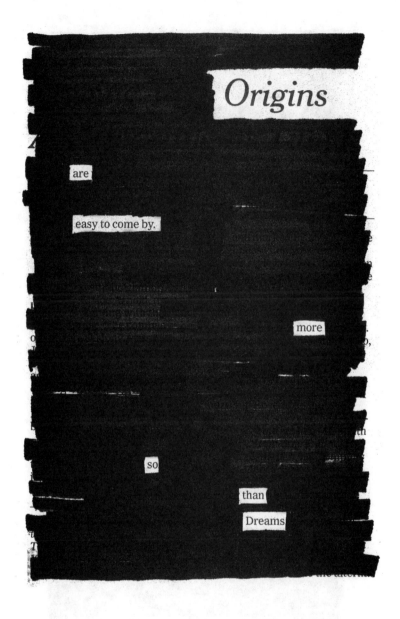

Origins
are
easy to come by,
more
so
than
Dreams

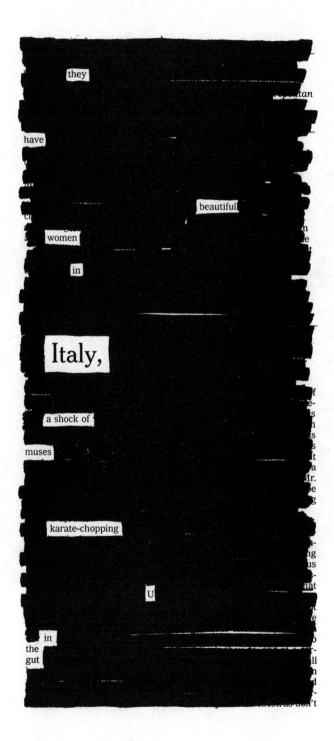

they

have

beautiful

women

in

Italy,

a shock of

muses

karate-chopping

U

in
the
gut

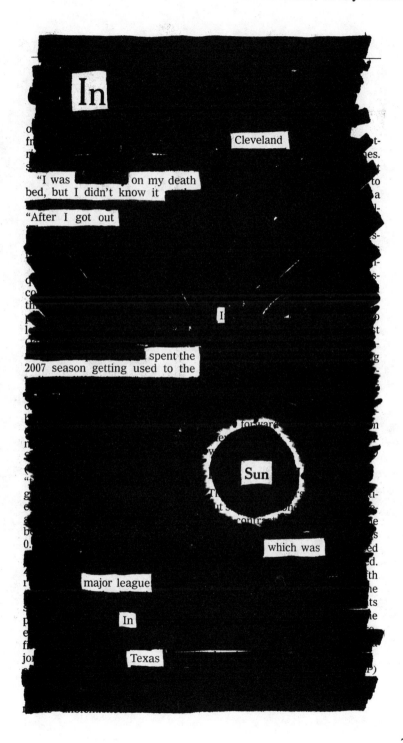

In

Cleveland

"I was on my death
bed, but I didn't know it

"After I got out

I

spent the
2007 season getting used to the

Sun

which was

major league

In

Texas

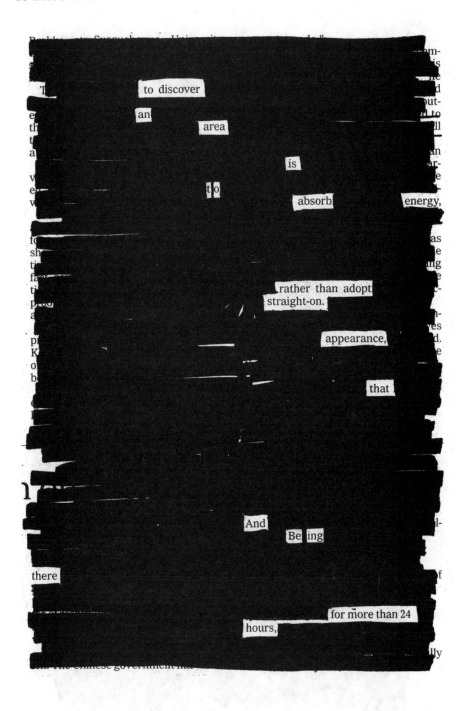

to discover

an

area

is

to absorb energy,

rather than adopt straight-on.

appearance,

that

And Beijing

there

for more than 24 hours,

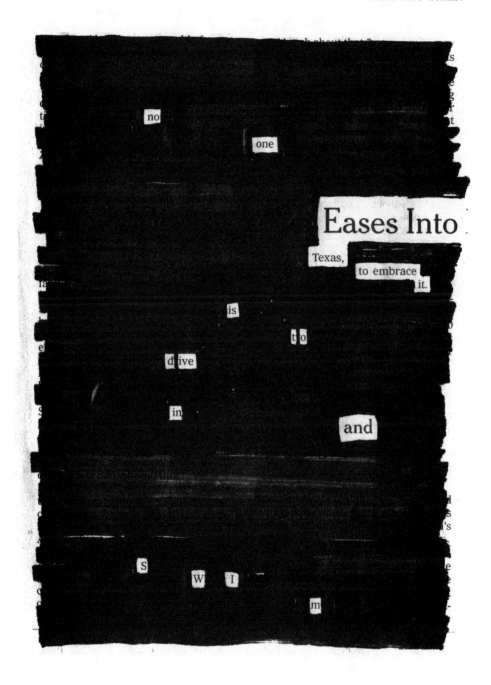

no one

Eases Into

Texas, to embrace it.

is to drive in and

S W I m

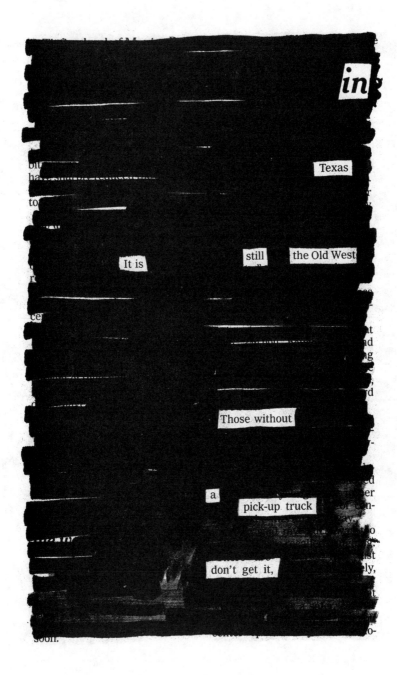

in

Texas

It is still the Old West

Those without

a

pick-up truck

don't get it,

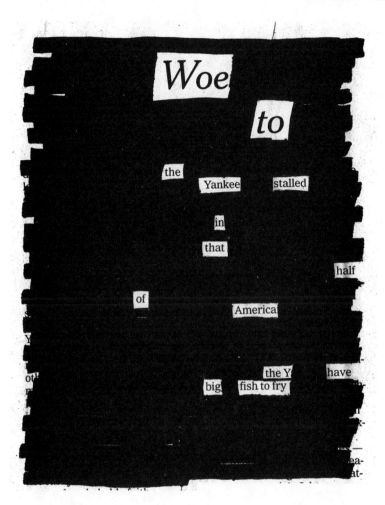

Woe

to

the

Yankee stalled

in

that

half

of

America

the Y have

big fish to fry

Cowboy Scene

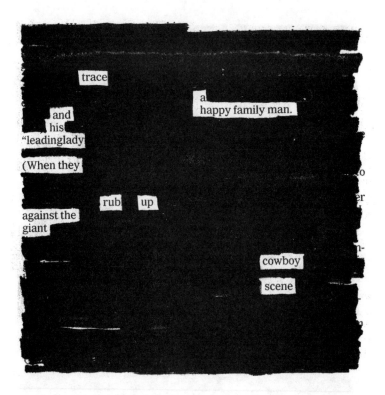

trace

a
happy family man.

and
his
"leadinglady

(When they

rub up

against the
giant

cowboy

scene

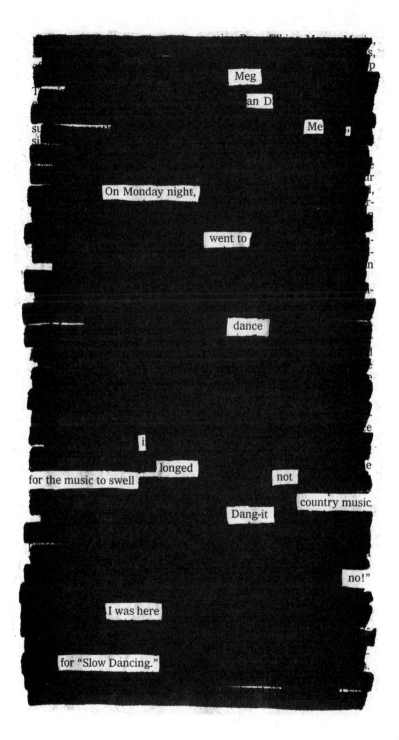

Meg

an D

Me ,

On Monday night,

went to

dance

i

longed

for the music to swell not

country music

Dang-it

no!"

I was here

for "Slow Dancing."

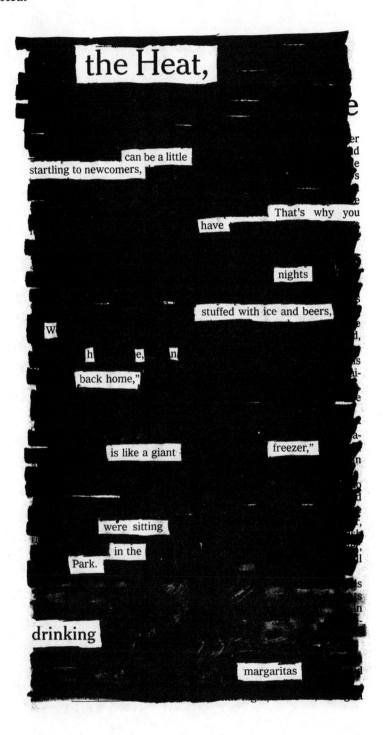

the Heat,

can be a little
startling to newcomers,

That's why you
have

nights

stuffed with ice and beers,

W

h e, n

back home,"

is like a giant freezer,"

were sitting
in the
Park.

drinking

margaritas

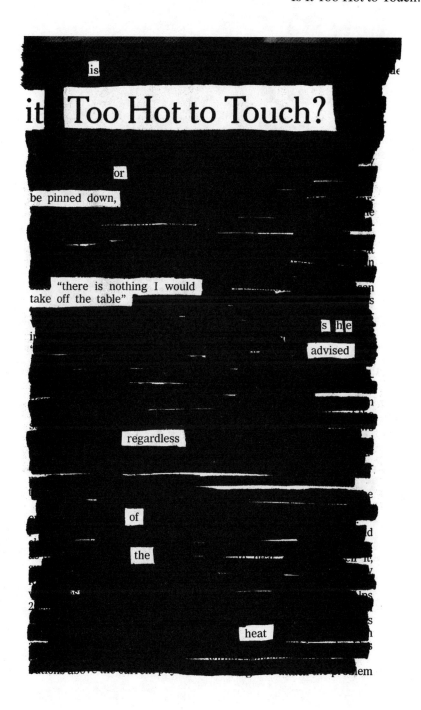

is

it **Too Hot to Touch?**

or

be pinned down,

"there is nothing I would
take off the table"

s he

advised

regardless

of

the

heat

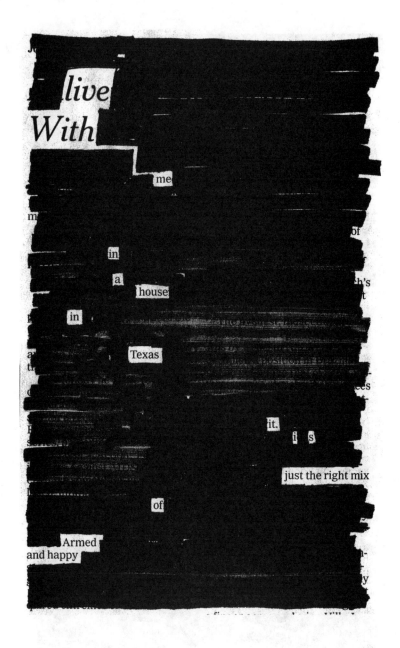

live
With me

in
a
house

in

Texas

it. i s

just the right mix

of

Armed
and happy

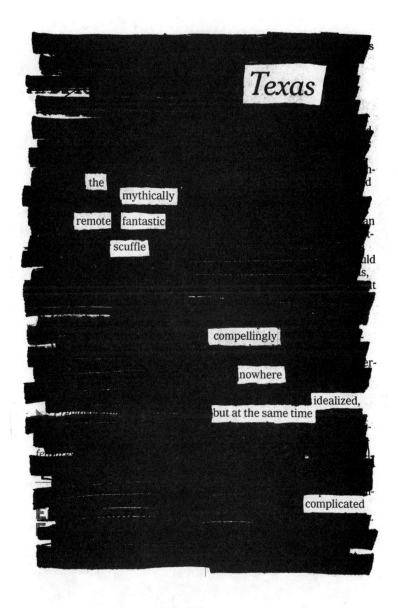

Texas

the mythically
remote fantastic
scuffle

compellingly

nowhere
idealized,
but at the same time

complicated

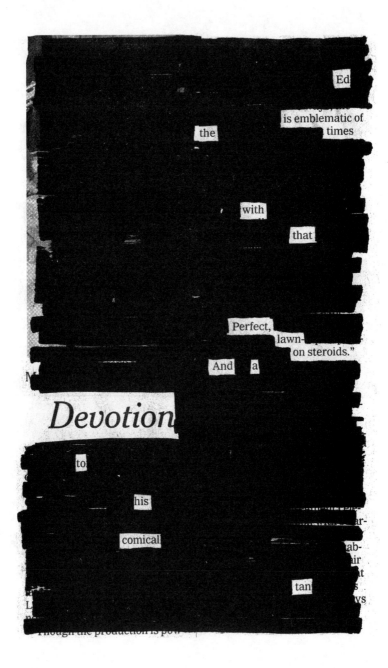

Ed

is emblematic of
times

the

with

that

Perfect,
lawn-
on steroids."

And a

Devotion

to

his

comical

tan

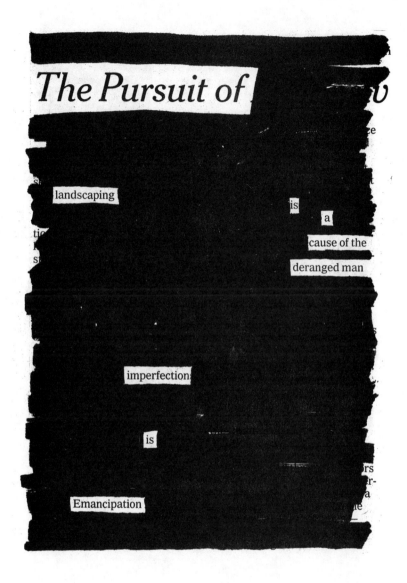

The Pursuit of

landscaping

is

a

cause of the

deranged man

imperfection

is

Emancipation

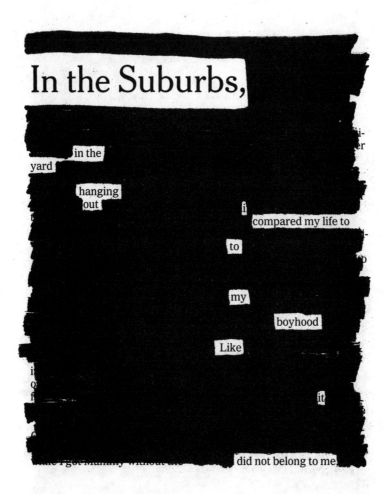

In the Suburbs,

in the
yard

hanging
out

i

compared my life to

to

my

boyhood

Like

it

did not belong to me

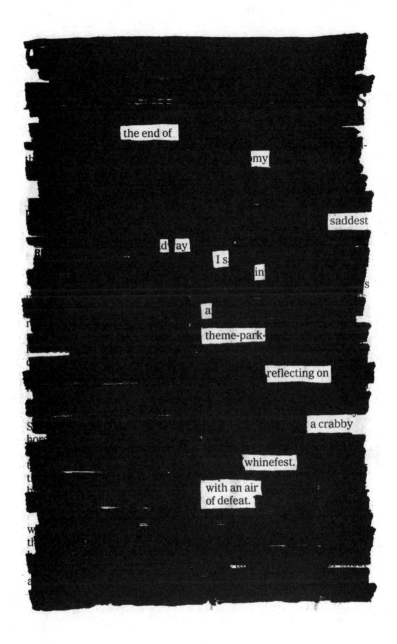

the end of

my

saddest

d ay I s in

a

theme-park-

reflecting on

a crabby

whinefest.

with an air
of defeat.

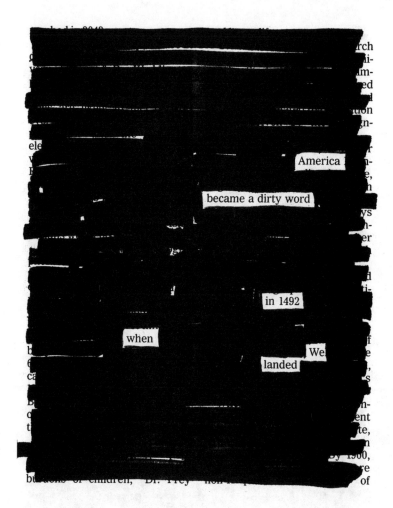

America became a dirty word in 1492 when We landed

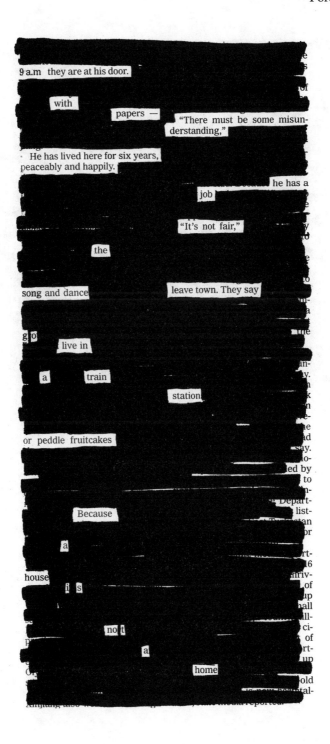

9 a.m they are at his door.

with

papers — "There must be some misun-
 derstanding,"

He has lived here for six years,
peaceably and happily.

 he has a
 job

 "It's not fair,"

 the

song and dance leave town. They say

go
 live in

a train

 station

or peddle fruitcakes

 Because

 a

house
 i s

 no t
 a

 home

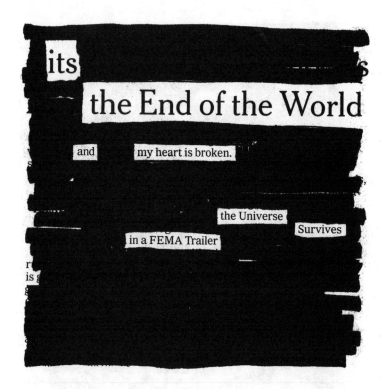

its

the End of the World

and my heart is broken.

the Universe

Survives

in a FEMA Trailer

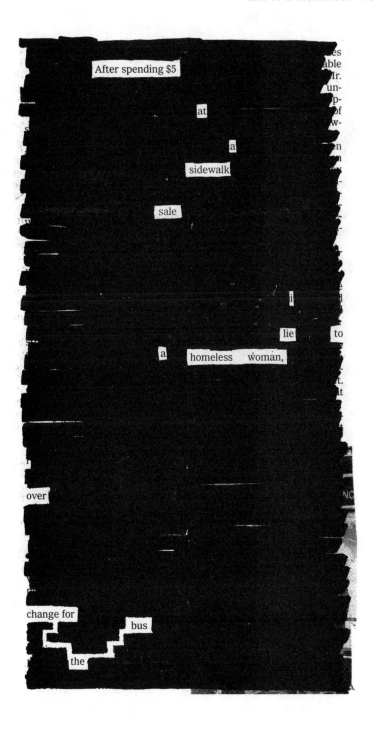

After spending $5

at

a

sidewalk

sale

i

lie to

a homeless woman,

over

change for bus

the

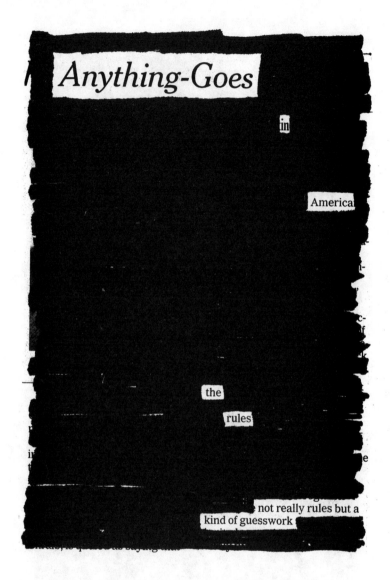

Anything-Goes

in

America

the

rules

not really rules but a
kind of guesswork

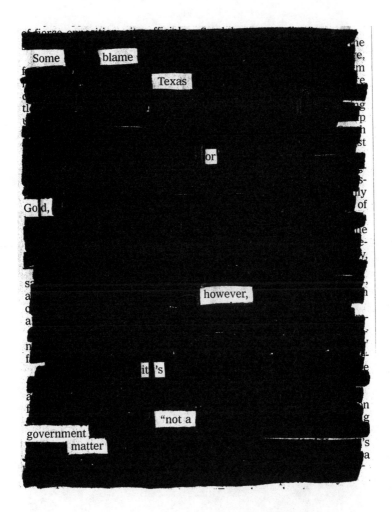

Some blame
Texas

or

Gold,

however,

it 's

"not a
government
matter

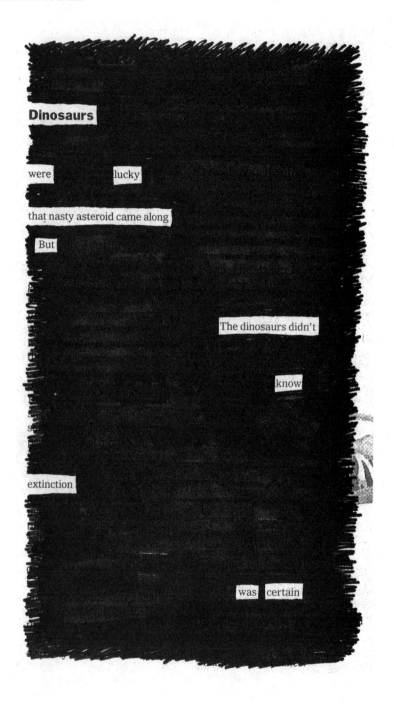

Dinosaurs

were lucky

that nasty asteroid came along

But

The dinosaurs didn't

know

extinction

was certain

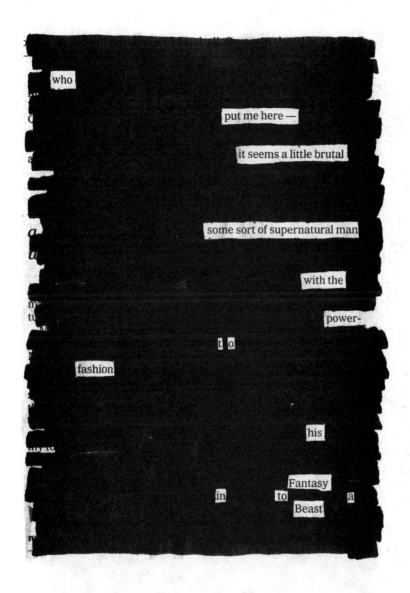

who

put me here —

it seems a little brutal

some sort of supernatural man

with the

power-

to

fashion

his

Fantasy
in to a
Beast

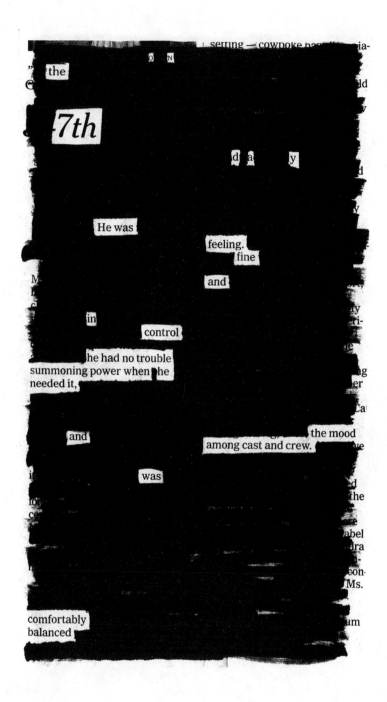

the

7th

day

He was

feeling.
fine

and

in

control

he had no trouble
summoning power when he
needed it,

and

the mood
among cast and crew.

was

comfortably
balanced

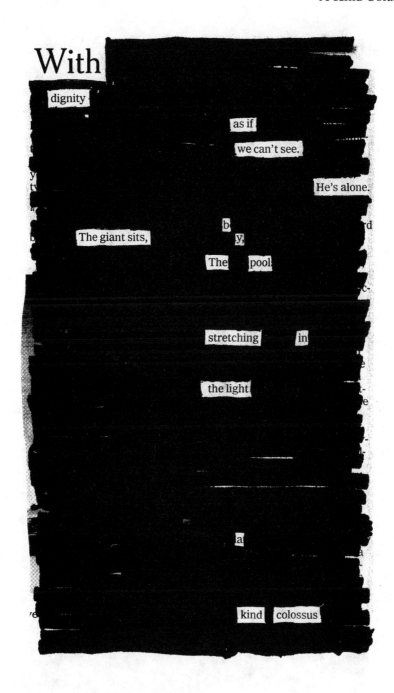

With

dignity

as if

we can't see.

He's alone.

The giant sits,

The pool

stretching in

the light

a

kind colossus

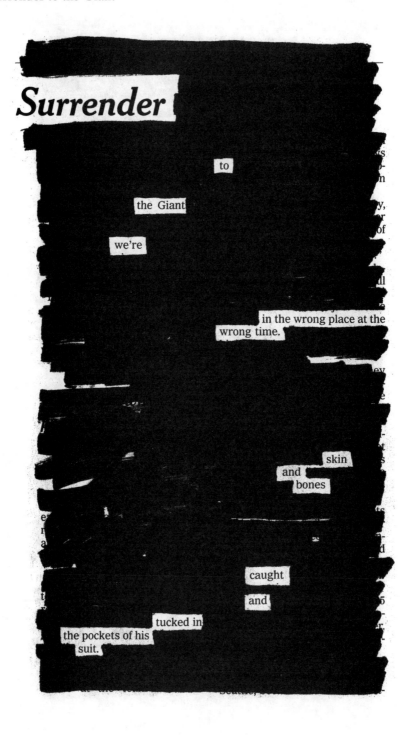

Surrender

to

the Giant

we're

in the wrong place at the wrong time.

skin
and
bones

caught

and

tucked in
the pockets of his
suit.

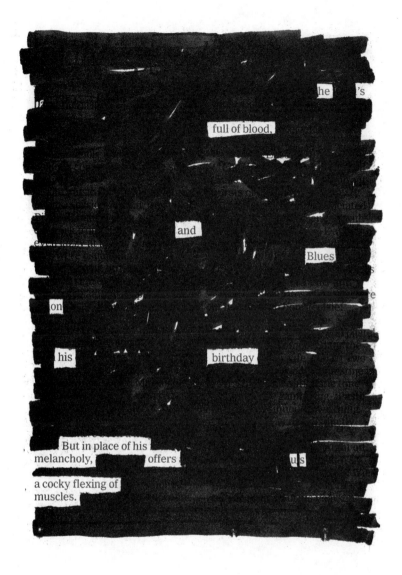

he 's

full of blood,

and

Blues

on

his birthday

But in place of his
melancholy, offers
us

a cocky flexing of
muscles.

Karaoke

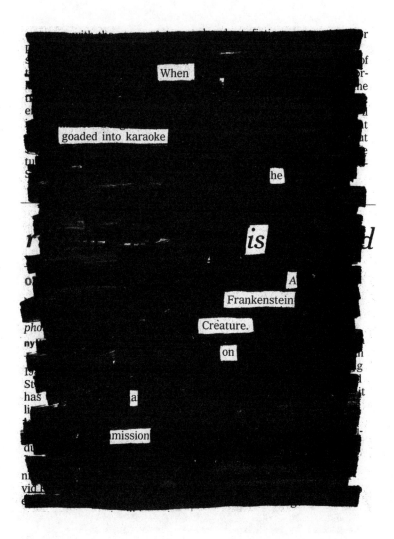

When

goaded into karaoke

he

is

A
Frankenstein
Creature.
on

a

mission

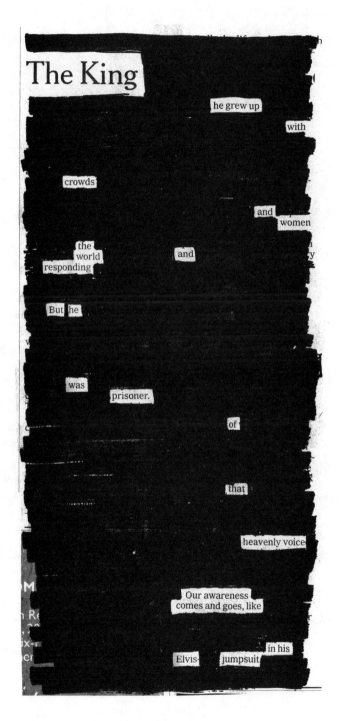

The King

he grew up

with

crowds

and
women

the
world
responding and

But he

was prisoner.

of

that

heavenly voice

Our awareness
comes and goes, like

in his
Elvis- jumpsuit

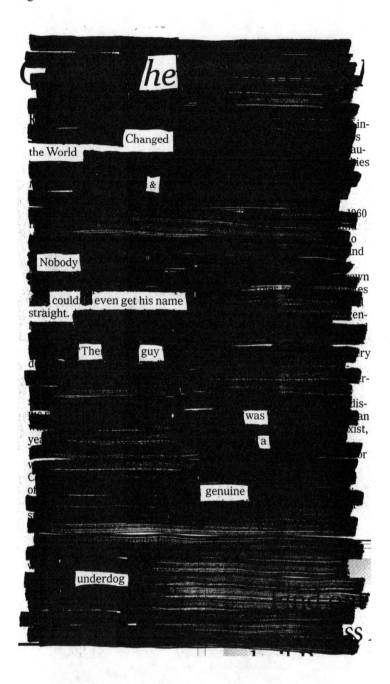

he Changed the World & Nobody could even get his name straight. 'The guy was a genuine underdog

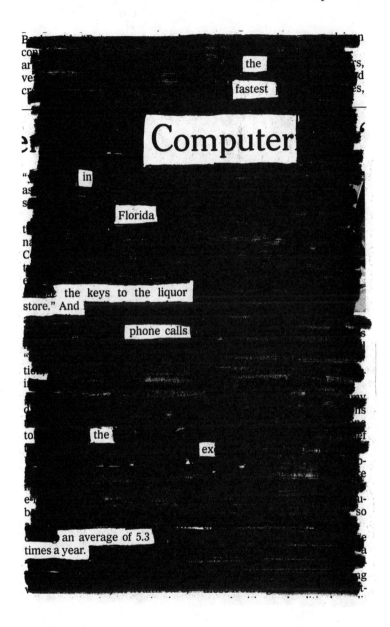

the
fastest

Computer

in

Florida

the keys to the liquor
store." And

phone calls

the
ex

an average of 5.3
times a year.

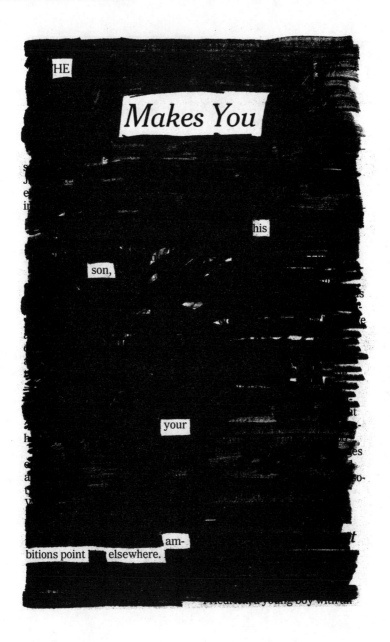

HE *Makes You* his son, your ambitions point elsewhere.

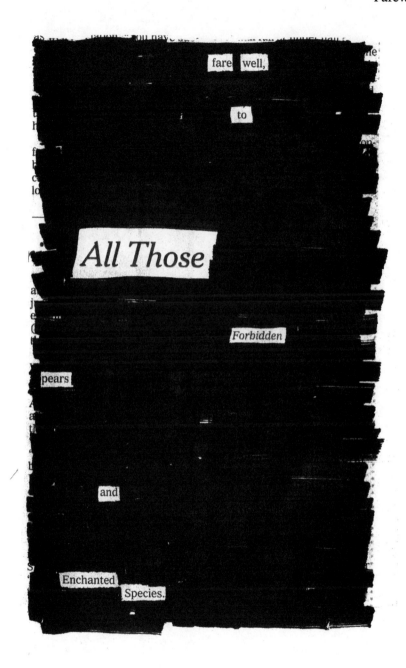

fare well,

to

All Those

Forbidden

pears

and

Enchanted
Species.

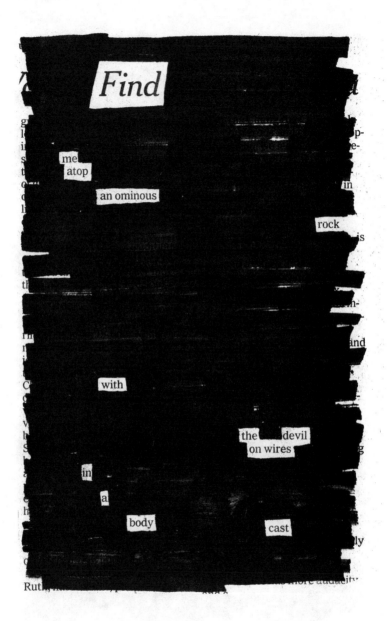

Find

me
atop

an ominous

rock

with

the devil
on wires

in

a

body

cast

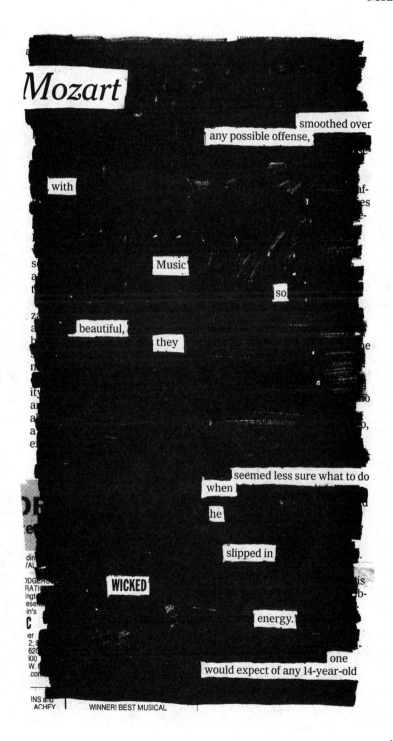

Mozart

smoothed over
any possible offense,

with

Music

so

beautiful,

they

seemed less sure what to do
when

he

slipped in

WICKED

energy.

one
would expect of any 14-year-old

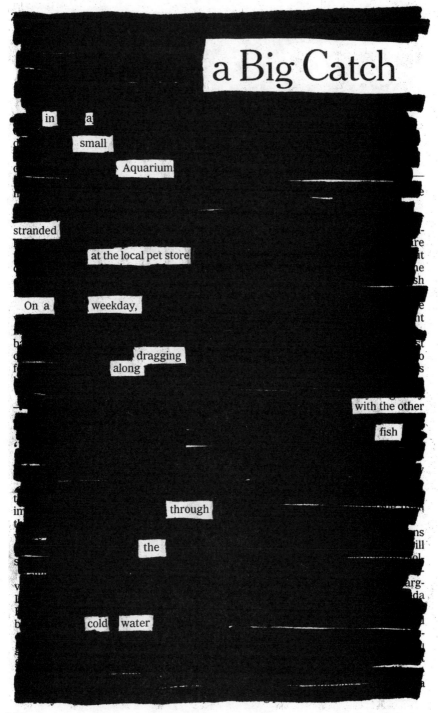

a Big Catch

in a
small
Aquarium

stranded

at the local pet store

On a weekday,

dragging
along

with the other

fish

through

the

cold water

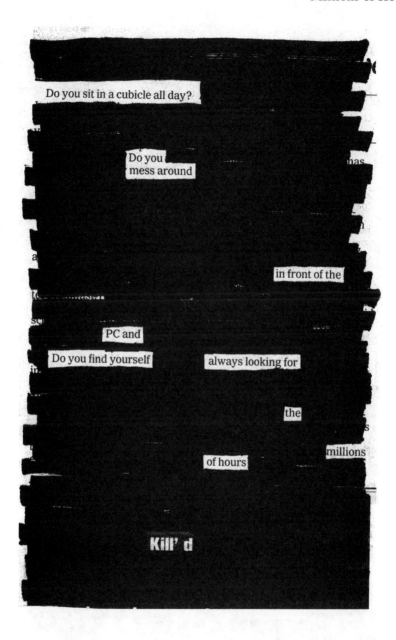

Do you sit in a cubicle all day?

Do you
mess around

in front of the

PC and
Do you find yourself always looking for

the

of hours millions

Kill' d

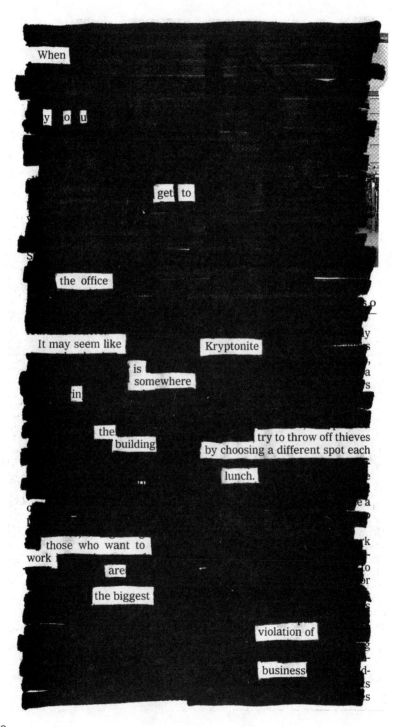

When

y o u

get to

the office

It may seem like Kryptonite

is
somewhere

in

the
building try to throw off thieves
 by choosing a different spot each

lunch.

those who want to
work
are

the biggest

violation of

business

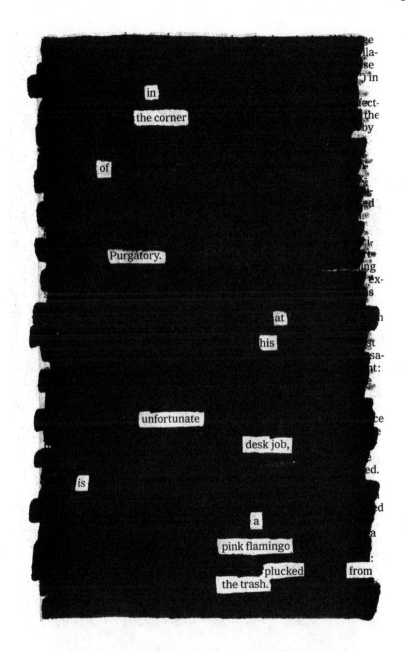

in
the corner

of

Purgatory.

at

his

unfortunate

desk job,

is

a

pink flamingo

plucked from
the trash.

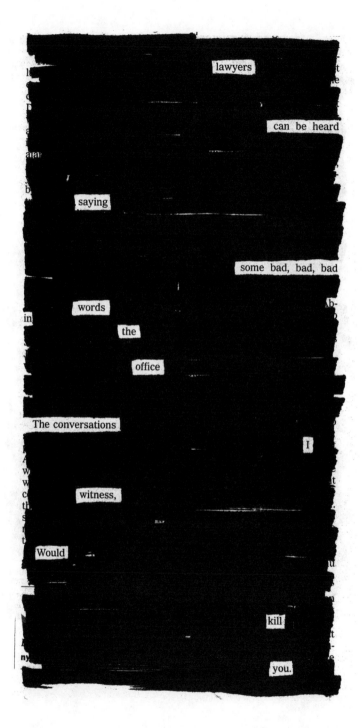

lawyers

can be heard

saying

some bad, bad, bad

words

the

office

The conversations

I

witness,

Would

kill

you.

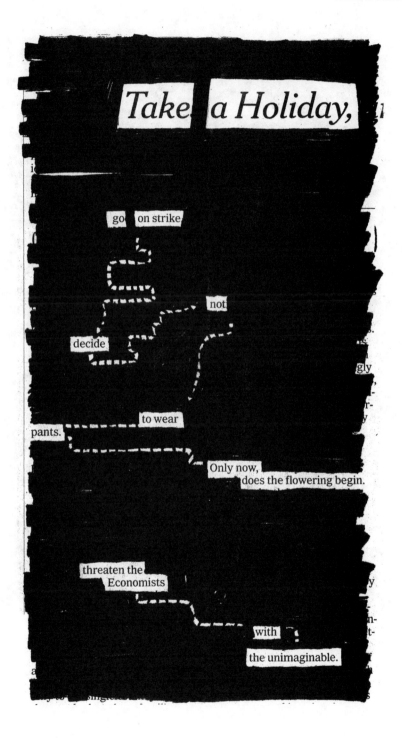

Take a Holiday,

go on strike

not

decide

to wear

pants.

Only now, does the flowering begin.

threaten the Economists

with

the unimaginable.

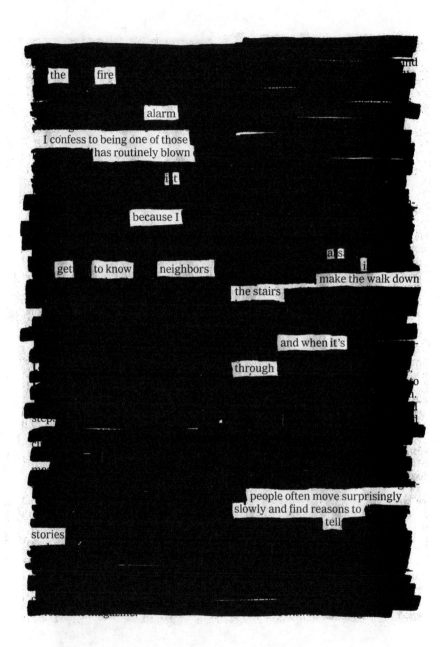

the fire

alarm

I confess to being one of those
 has routinely blown

it

because I

a s
 i
 make the walk down

the stairs

 and when it's

through

people often move surprisingly
slowly and find reasons to
 tell

stories

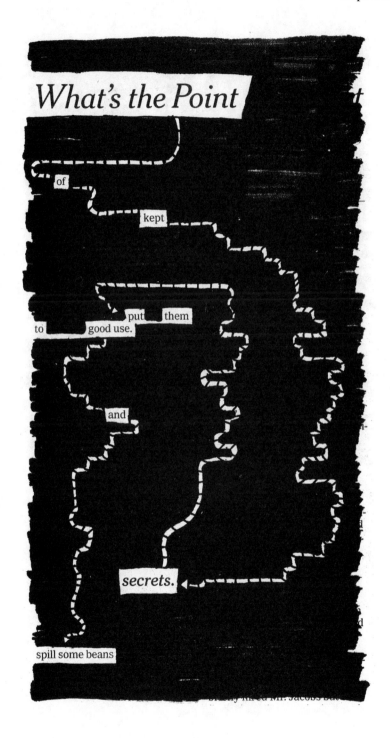

What's the Point

of

kept

put them

to good use.

and

secrets.

spill some beans

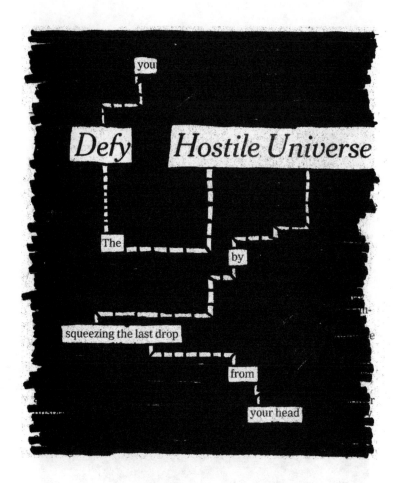

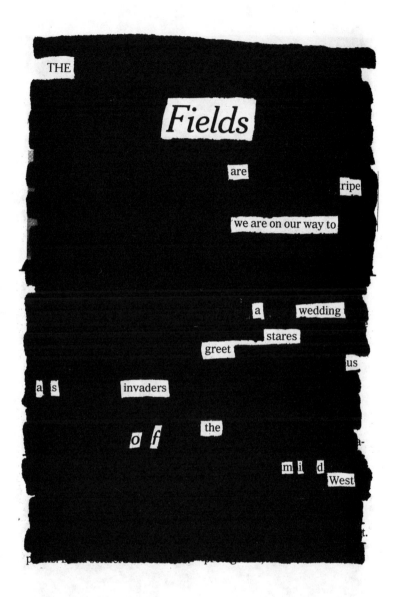

THE

Fields

are

ripe

we are on our way to

a wedding

stares

greet

us

a s invaders

o f the

m i d West

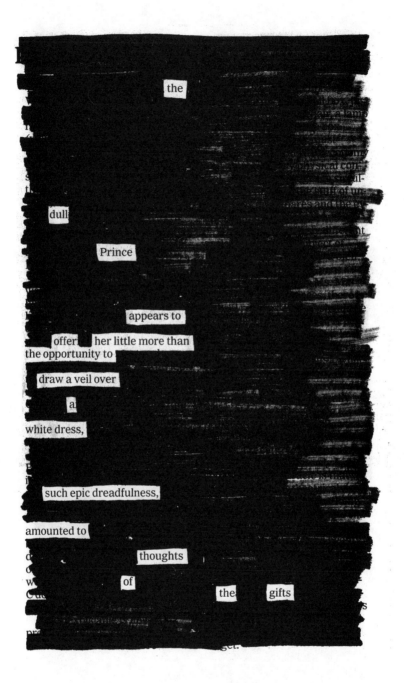

the

dull

Prince

appears to

offer her little more than
the opportunity to

draw a veil over

a

white dress,

such epic dreadfulness,

amounted to

thoughts

of

the gifts

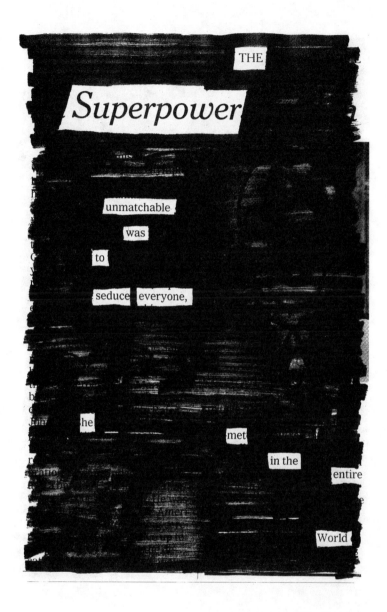

THE *Superpower*

unmatchable was to seduce everyone, he met in the entire World

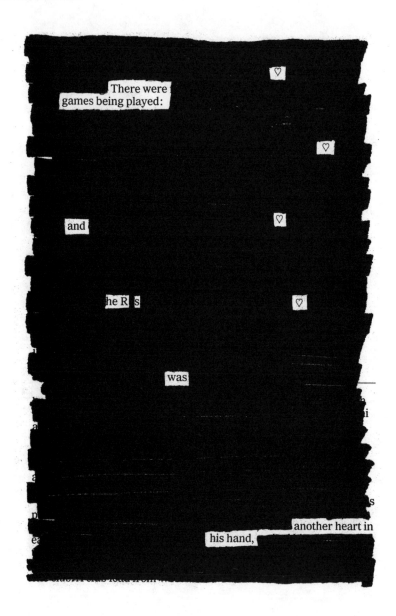

There were
games being played:

and

he R s

was

another heart in
his hand,

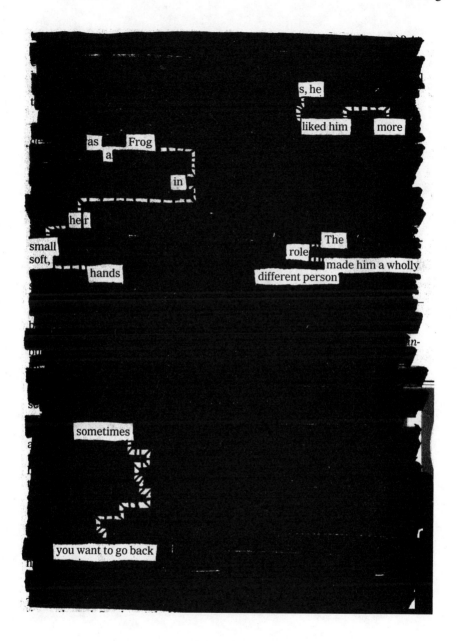

s, he

liked him more

as Frog
 a

 in

 her

small
soft, The
 role
 hands made him a wholly
 different person

sometimes

you want to go back

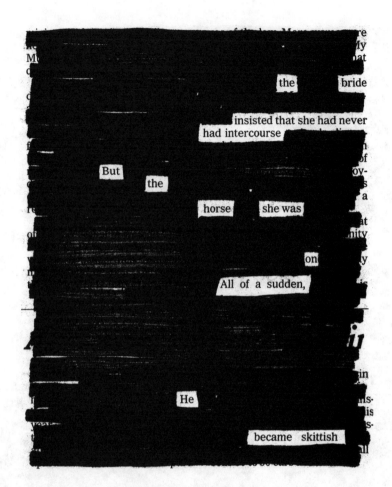

the bride

insisted that she had never
had intercourse

But
the

horse she was

on

All of a sudden,

He

became skittish

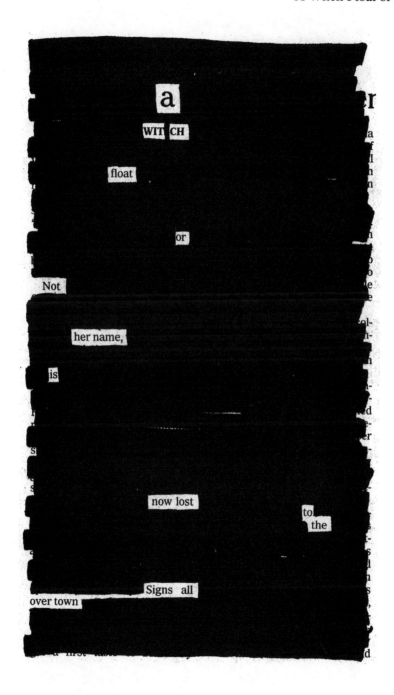

a

WIT CH

float

or

Not

her name,

is

now lost

to the

Signs all

over town

Shoulders

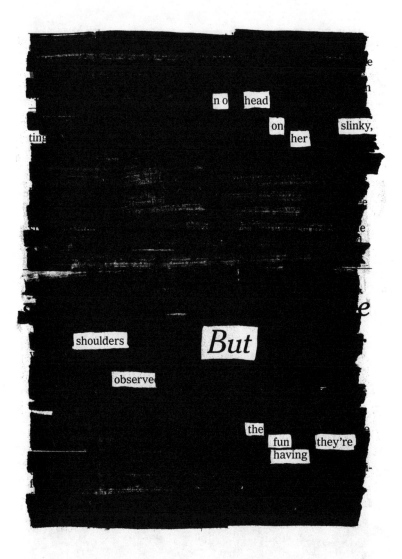

no head
on her slinky,

shoulders **But**

observe

the
fun they're
having

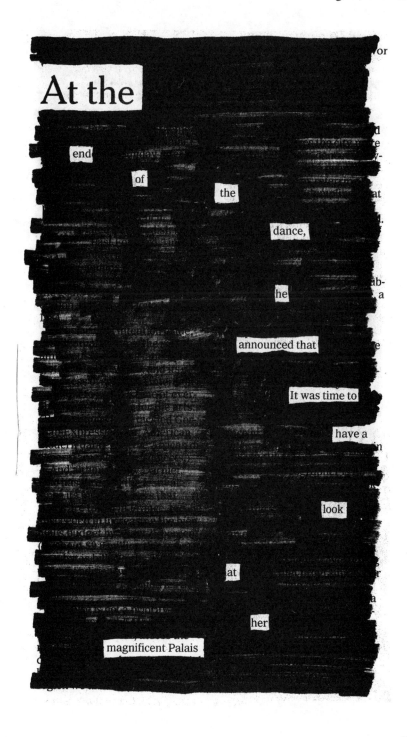

At the

end

of

the

dance,

he

announced that

It was time to

have a

look

at

her

magnificent Palais

Kickboxing

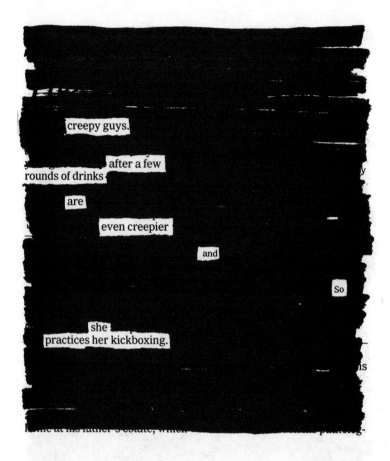

creepy guys.

after a few
rounds of drinks

are

even creepier

and

So

she
practices her kickboxing.

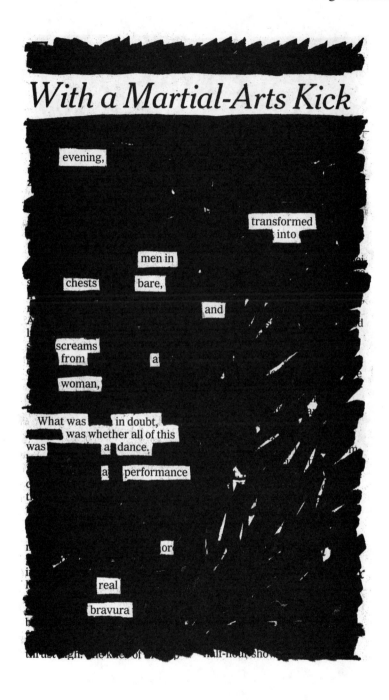

With a Martial-Arts Kick

evening,

transformed
into

men in

chests bare,

and

screams
from a

woman,

What was in doubt,
 was whether all of this
was a dance,

a performance

or

real

bravura

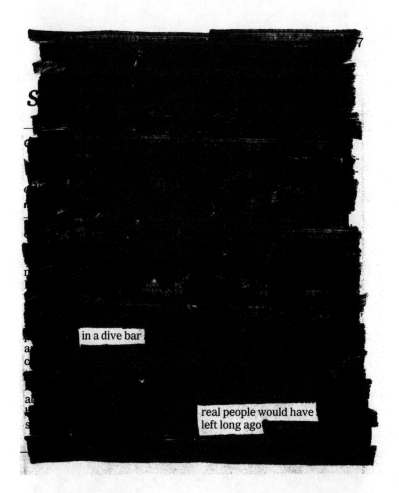

in a dive bar

real people would have
left long ago

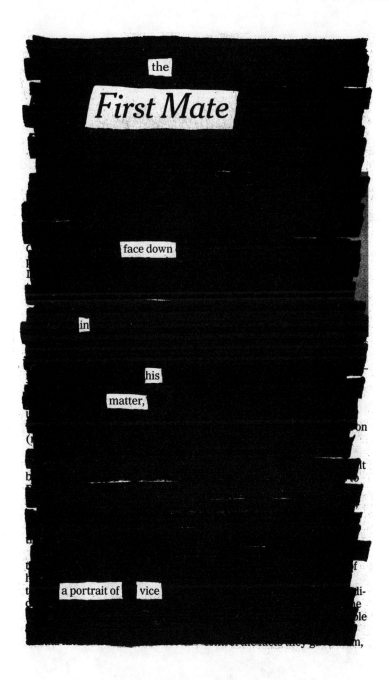

the

First Mate

face down

in

his

matter,

a portrait of vice

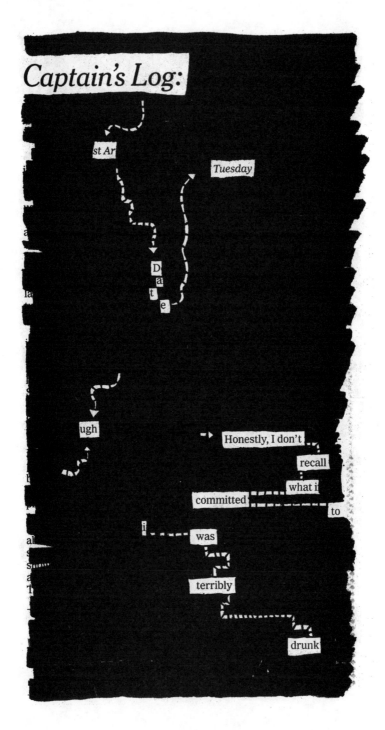

Captain's Log:

st Ar

Tuesday

D
a
t
e

ugh

Honestly, I don't

recall

what i

committed

to

i

was

terribly

drunk

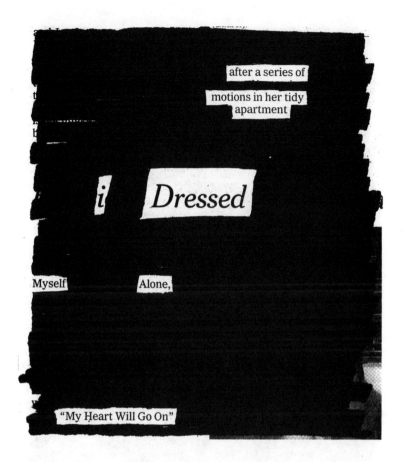

after a series of

motions in her tidy
apartment

i Dressed

Myself Alone,

"My Heart Will Go On"

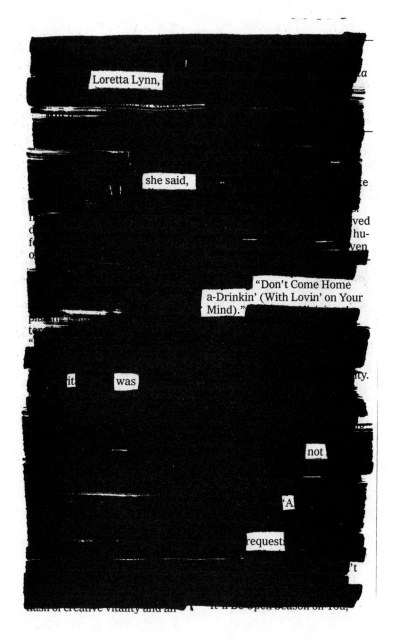

Loretta Lynn,

she said,

"Don't Come Home
a-Drinkin' (With Lovin' on Your
Mind)."

it was

not

'A

request

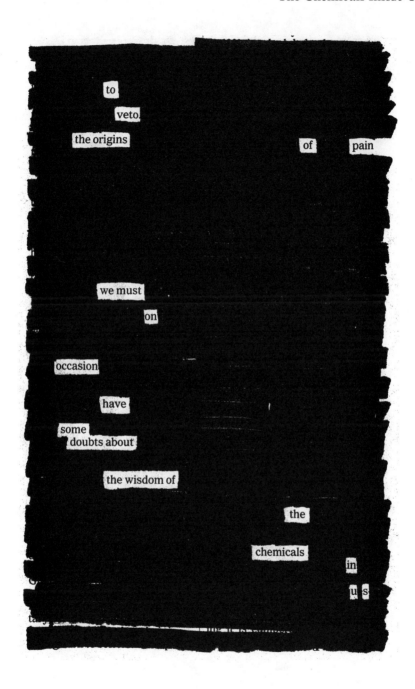

to
veto.
the origins of pain

we must
on

occasion

have
some
doubts about

the wisdom of

the

chemicals
in
us

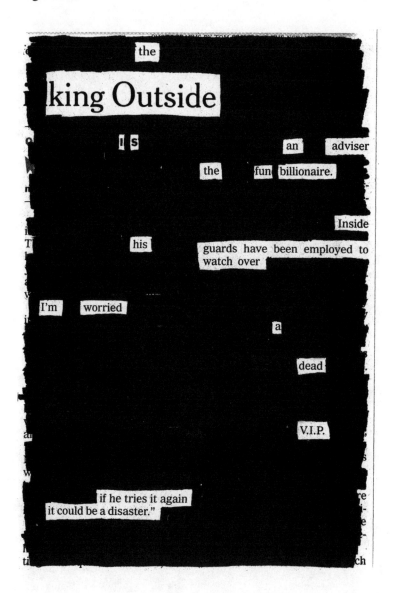

the

king Outside

is

an adviser

the fund billionaire.

Inside

his guards have been employed to
watch over

I'm worried

a

dead

V.I.P.

if he tries it again
it could be a disaster."

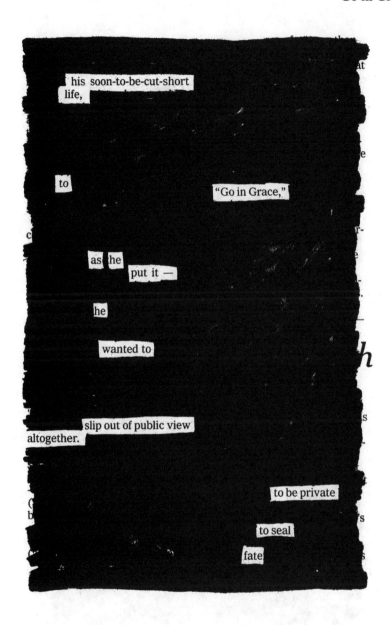

his soon-to-be-cut-short
life,

to "Go in Grace,"

as he
put it —

he

wanted to

slip out of public view
altogether.

to be private

to seal

fate

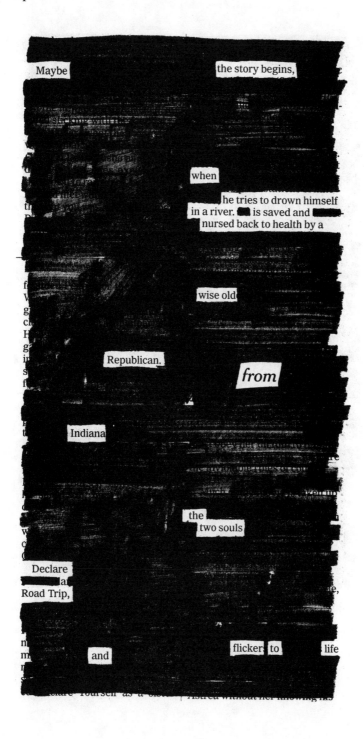

Maybe the story begins,

when

he tries to drown himself in a river. ▮ is saved and ▮ nursed back to health by a

wise old

Republican. *from*

Indiana

the two souls

Declare Road Trip,

and flickers to life

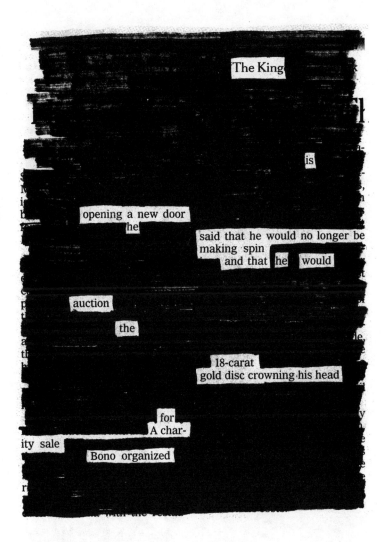

The King

is

opening a new door
he
said that he would no longer be
making spin
and that he would

auction

the

18-carat
gold disc crowning his head

for
A char-
ity sale
Bono organized

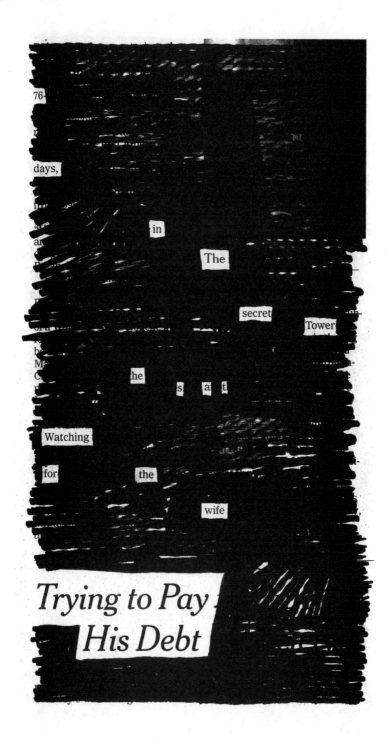

The secret Tower

in

he s a t

Watching

for the

wife

Trying to Pay
His Debt

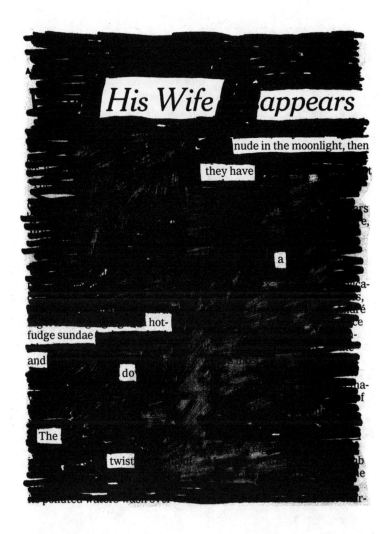

His Wife *appears*

nude in the moonlight, then

they have

a

hot-
fudge sundae

and

do

The

twist

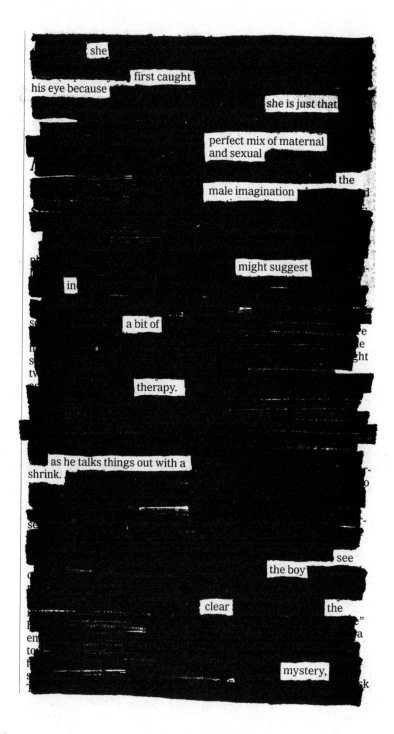

she

first caught

his eye because

she is just that

perfect mix of maternal
and sexual

the

male imagination

might suggest

in

a bit of

therapy.

as he talks things out with a
shrink.

see

the boy

clear the

mystery,

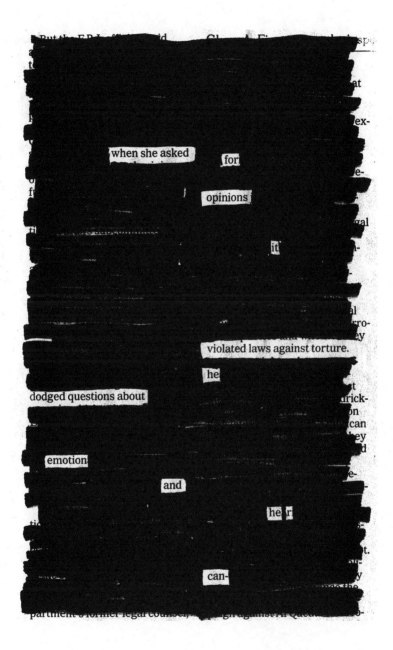

when she asked for opinions it violated laws against torture. he dodged questions about emotion and her can-

Smile

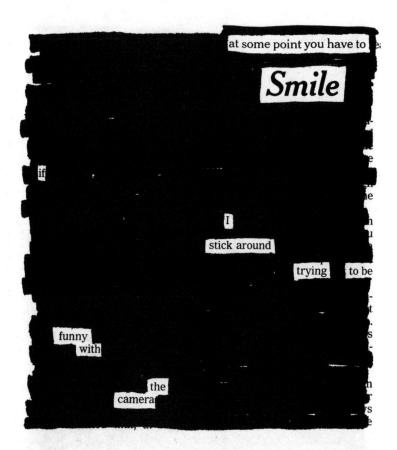

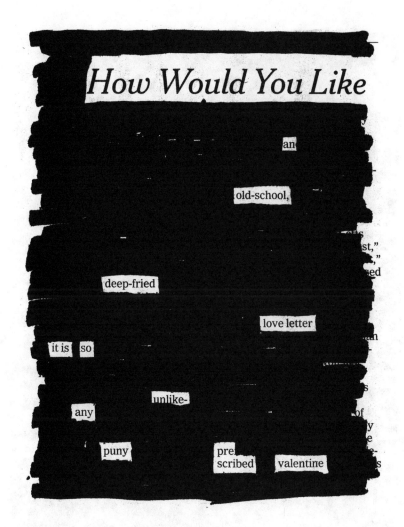

How Would You Like

an

old-school,

deep-fried

love letter

it is so

unlike-

any

puny

pre-
scribed valentine

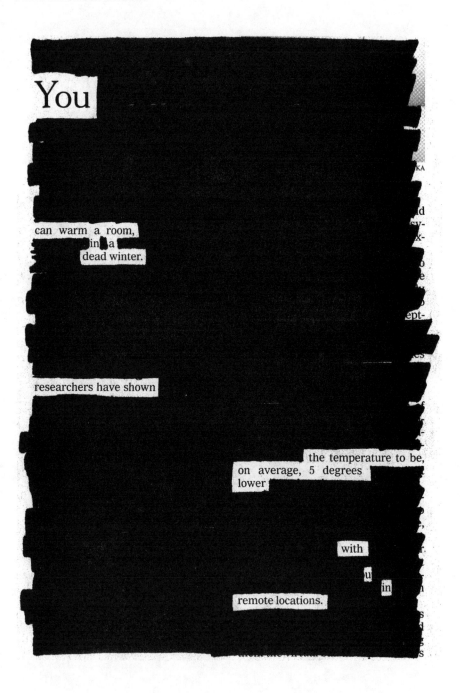

You

can warm a room,
in a
dead winter.

researchers have shown

the temperature to be,
on average, 5 degrees
lower

with

u

in

remote locations.

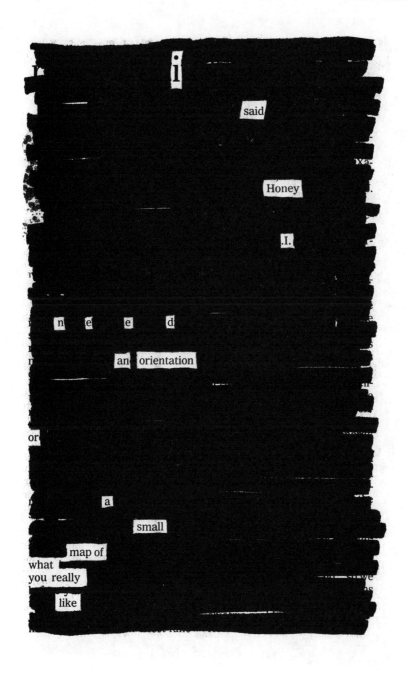

i

said

Honey

I.

n e e d

an orientation

a

small

map of

what

you really

like

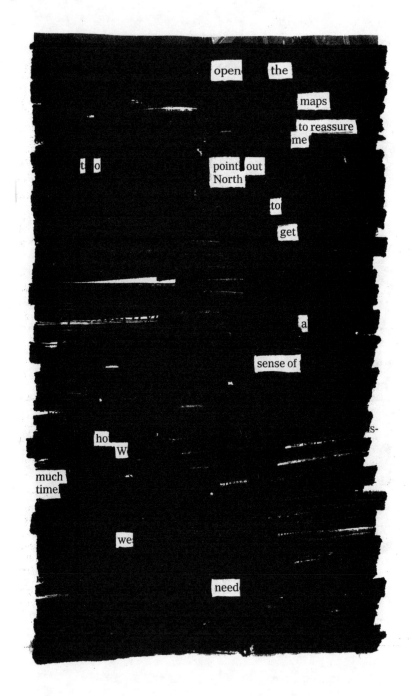

open the

maps

to reassure
me

t o

point out
North

to

get

a

sense of

ho s-
W

much
time

we

need

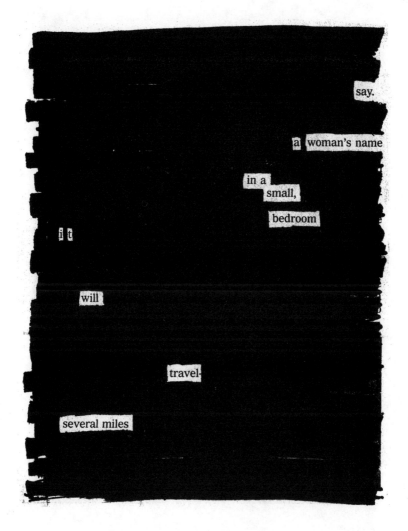

say.

a woman's name

in a
small,

bedroom

i t

will

travel-

several miles

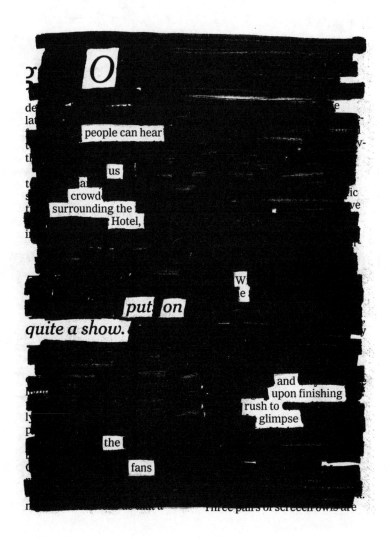

O

people can hear

us

crowd

surrounding the
Hotel,

We

put on

quite a show.

and
upon finishing
rush to
glimpse

the

fans

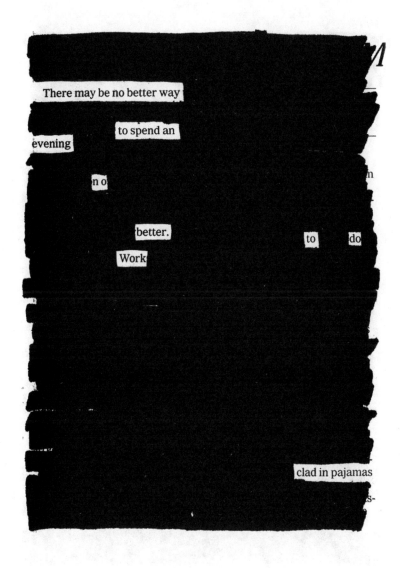

There may be no better way

to spend an

evening

n o

better.

Work

to do

clad in pajamas

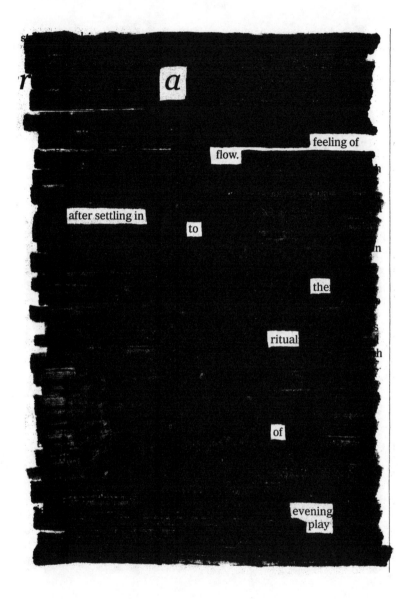

r a

feeling of

flow.

after settling in to

the

ritual

of

evening play

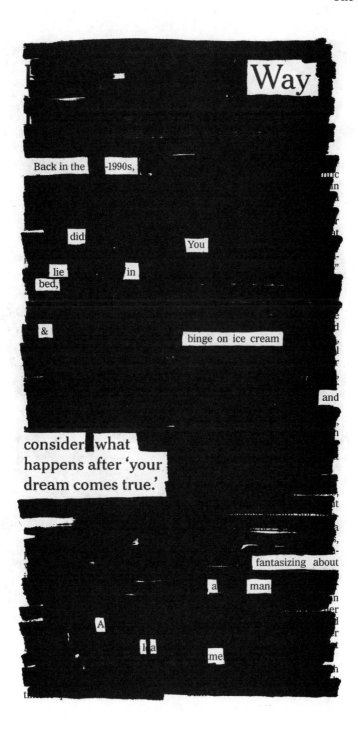

Way

Back in the -1990s,

did You

lie in
bed,

& binge on ice cream

and

consider what
happens after 'your
dream comes true.'

fantasizing about

a man

A

l a

me

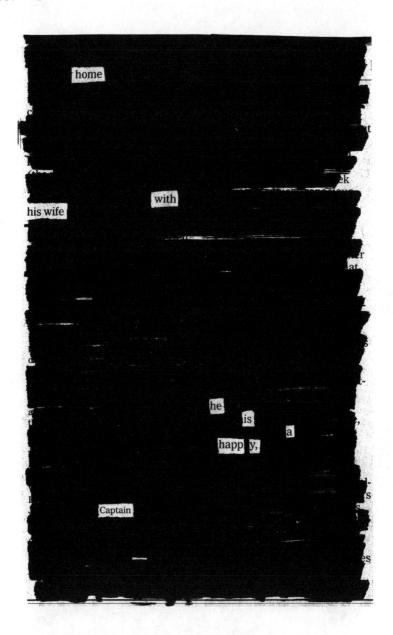

home

with

his wife

he

is

a

happy,

Captain

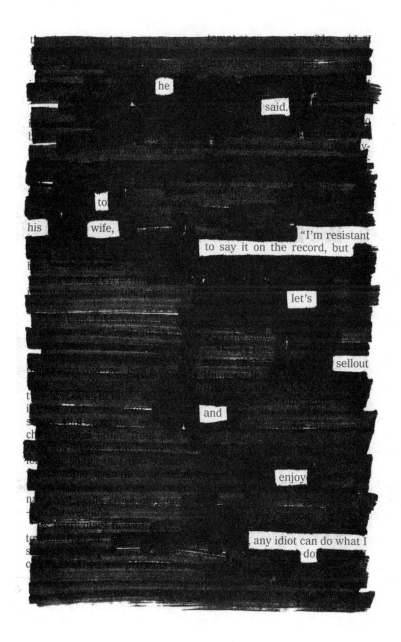

he

said.

to

his wife, "I'm resistant
to say it on the record, but

let's

sellout

and

enjoy

any idiot can do what I
do

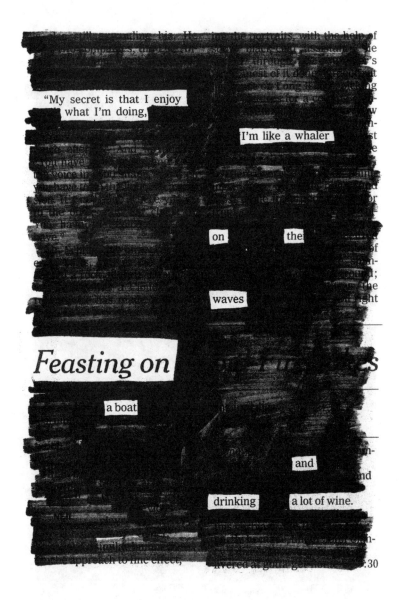

"My secret is that I enjoy what I'm doing,

I'm like a whaler

on the

waves

Feasting on

a boat

and

drinking a lot of wine.

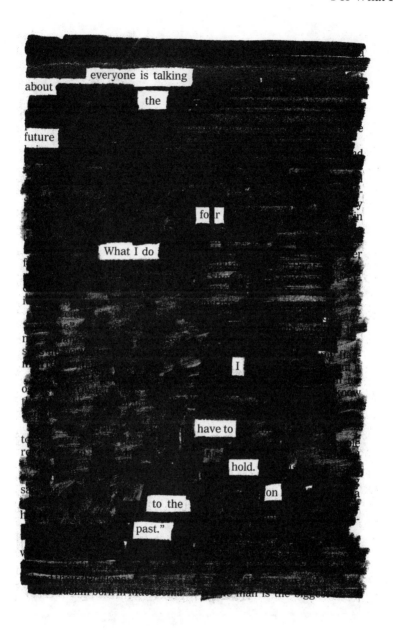

about everyone is talking
the
future
fo r
What I do
I
have to
hold.
on
to the
past."

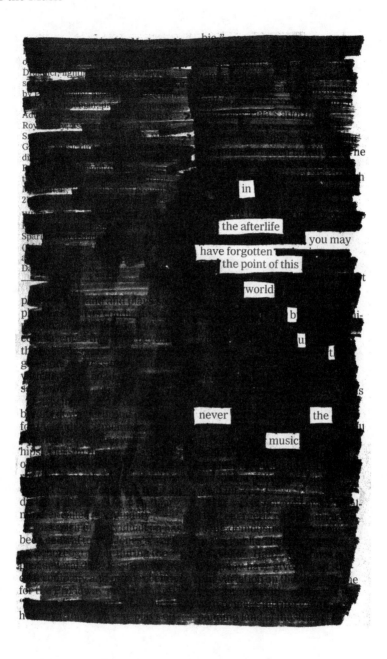

in

the afterlife

you may

have forgotten
the point of this

world

b

u

t

never

the

music

How to Make

a Newspaper

Blackout Poem

How to Make a Newspaper Blackout Poem

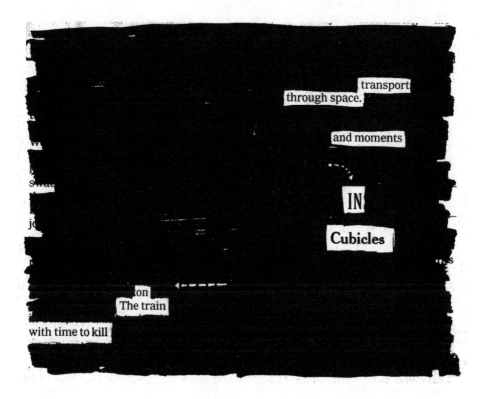

The poet William Carlos Williams said it was difficult to get the news from poems, but I've found it's not all that hard to get poems from the news.

In fact, it couldn't be simpler. Here's the recipe:

Grab a newspaper.
Grab a marker.
Find an article.
Cross out words, leaving behind the ones you like.
Pretty soon you'll have a poem.

That's it. Really. No reason to read on any further. Put down this book and try it out.

Not convinced? Think you're not a poet? Check out the poems at the end of this book—they were all made by folks just like you . . . from newspaper articles that were one hundred years old!

Okay, maybe you'll still have a couple questions. Here are questions a few folks have asked me:

What newspaper should I use?

Whatever's around! No need to get fancy. You can use a national paper or your little hometown paper. You can use today's, yesterday's, or last week's. All that's important is that you have a bunch of words to work with.

And if there's nothing lying around, go out and buy a paper. Lord knows the industry could use some sales. (And if you're reading this book in the future, when newspapers are supposedly extinct, I'm sure there are still printers.)

What kind of markers should I use?

Whatever's on sale! I like to use a big, fat, chisel-tip marker for the heavy-duty marking, and a fine-point felt-tip marker for detail work.

But who says you have to use a marker? You can use a ballpoint pen. You can use a paintbrush. Whatever gets the job done and suits your imagination.

(Check out Tom Phillips's *A Humument* and Google "altered books" for amazing examples of what you can do to pages with different art supplies.)

What section makes for the best poems?

Although I'm on record lamenting the business section as being the worst section for poetry, even there you can still find some gems. I use all the sections, but I especially like Arts and Metro. Arts because the writers often write about themes and plots, and Metro because it's often about people and what they do around town. The Sports section is fun for place names. (For an example, see the poem, "In Cleveland, on My Deathbed," in this collection.)

How in the world do I even get started?

What you're doing when you're making a blackout poem, in the words of Allen Ginsberg, is "shopping for images." You want to begin by looking

for a word, or a combination of words, that forms an image in your head. (Tip: the best images are usually made up of nouns and verbs.) You want an *anchor*—a place to start. If you identify this anchor, it's easy to branch out from there.

Once you identify your anchor, you want to move around the page and find words and phrases you can link to that anchor. Try not to have a preconceived notion of where you want to go. Let the method take you for a ride.

Also: remember that Westerners read left to right, top to bottom. Poems read best and they're easier to make if you follow this rule. For example, if you're looking for a word or phrase *before* your anchor, it would be above or to the left. If you're looking for a word *after* your anchor, it should be below or to the right.

You can cheat the left-to-right, top-to-bottom rule by using little trails of white space to lead you in between words. (Tom Phillips calls these "rivers.") There are tons of examples in this book.

I circle or draw a box around the words and phrases I like as I'm working, and black out the unwanted words later. If you're a real scaredy cat, you can use a pencil when you're starting out.

I still can't get started! There are too many possibilities!

The solution to any writer's block is to place some constraints on yourself.

Identify the size you want your poem to be. I've done blackout poems from a few paragraphs, and I've done full-page broadsheet poems. All the poems in this book were done with two columns of newspaper—the perfect width for a paperback book. When I was working on it, I'd grab a pair of scissors and randomly cut up the paper into two-column strips of varying lengths. Sometimes I'd use the ending of one article and the beginning of another, or the right column of one article, and the left column of another. I stuffed these strips into a folder and carried it around for easy access. (It's almost impossible to open a newspaper on a crowded bus.) Regardless of the size you choose, your goal is to find a poem in that section of newsprint.

I also recommend setting a time limit. I used the time limits of my bus ride and my lunch break.

And rest assured: some articles just don't work. Toss those in the recycle bin and move on to the next!

Do you read the articles first?

The answer might surprise you: No!

I've found that if I read the article beginning to end, I get swept up in the writing and the stories. It colors my impressions of the words, and I can't see the trees for the forest.

I like to think of blackout poems like those old "Word Find" and "Word Search" puzzles we used to do in elementary school—a field of letters with hidden messages to find. The more I treat the newspaper as raw material and less as writing, the better my poems get.

Your results may vary, of course. Try it both ways and see what happens.

Okay, I've made some poems. Now what?

It's up to your imagination. When I first started doing the poems, I'd use the little scenes I'd made to think up characters and plots for short stories. You can use the poems as brainstorming for your art, your writing, or even that big term paper or business meeting. You can paste them into your notebook or keep them as a diary.

It's best to share them! Poems are meant to be read. You can collect a batch of the poems and photocopy them into zines to pass out to your friends. You can scan them and post them to your blog or your Web site. You can use them with your kids, or with your grandparents, in a classroom, or in a writing group.

Wherever you decide to go with the method, the poems are their own reward. By making writing pleasurable—by making it more like a game and less like hard work—you can pull things out of your brain that you've never dreamed of.

Have fun, and let me know how it goes!

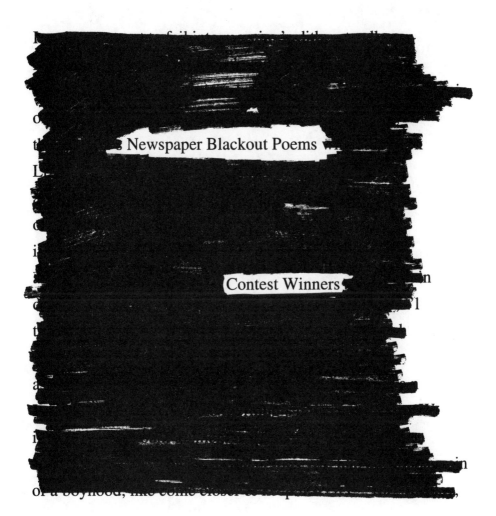

Newspaper Blackout Poems

Contest Winners

Newspaper Blackout Poems
Contest Winners

The following poems were winners of a contest I ran in the fall of 2008. Each poem was made from a hundred-year-old newspaper article!

These five poets, regular folks with day jobs, whether consciously or unconsciously, all followed my tips to good results: they started with anchor words that conjured vivid images in their minds, they connected those anchors with other words (and sometimes trails of white space to make those words readable), and, most important, they used their imaginations to transform a newspaper article into poetry. All it took was some downtime and something that marks. I hope they will be an inspiration for you to try your own!

"ROACH STAIN" BY ALISON CONLON

This poem does everything I think a great blackout poem should do: it transforms the original article (about a horrific construction accident) into a completely different image, it reads cleanly from left to right and top to bottom, and, best of all, it has a sense of humor. Alison did this poem to pass the time on her long train ride to and from her work in the Boston area. She told me that starting from the original article was daunting, but once she found the anchor words "crushed," "roach," and "kitchen," she simply looked for the right words to pull them together. Note the way she drew geometric shapes around the words (everything is either a triangle, a rectangle, or a circle), and her innovations with the text, combining "struggle-ing" and "m-y."

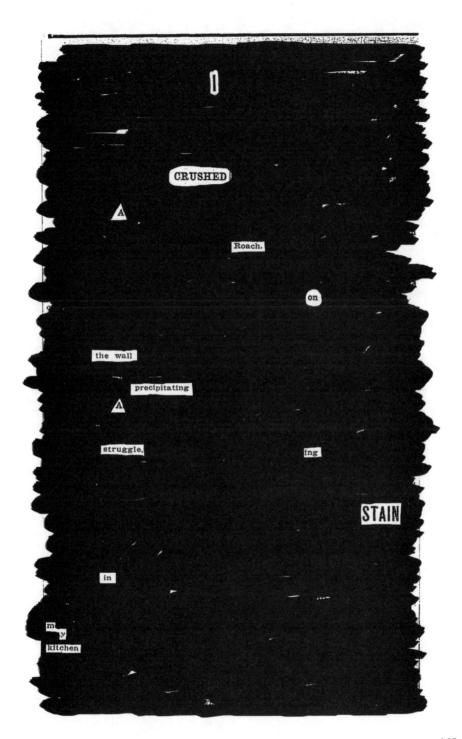

O

CRUSHED

A

Roach.

on

the wall

precipitating

A

struggle, ing

STAIN

in

m y
kitchen

"CLUE" BY PETER BOET

Like Alison's, Peter's poem began with anchor words: when he saw "re-volver" and "dining room" together, it reminded him of the board game Clue. Peter, a civil engineer from Grand Haven, Michigan, told me, "I was pretty sure I wasn't going to find Professor Plum or Colonel Mustard . . . I was searching for Mr. Green when I stumbled upon Mrs. White hanging out near the lower left-hand corner." He then finished the poem by linking the three anchors. Note the way he blacked out the word "Clue"—you can use this method to not only draw letters, but also shapes and pictures!

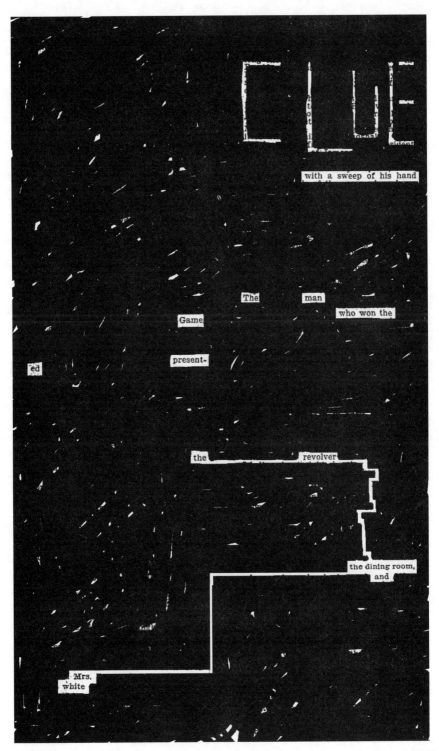

CLUE

with a sweep of his hand

The man
 who won the
 Game

 present-
ed

 the revolver

 the dining room,
 and

 Mrs.
 white

"THE WALRUS MAKES A TOAST" BY STEPHANIE CHENG

Stephanie's poem was made from the same article as Peter's poem, and while they're both references to pop culture, the only overlap between the two are the words "dining room." Then a med student in Ann Arbor, Michigan, Stephanie liked to read my Web site in between patients during slow clinic days, and one of her favorite poems of mine was called "Adventures in the Batsuit." She liked the way the allusion to Batman's backstory made the poem richer, so when she saw the anchor words "oyster" and "steam" in the text, she thought of Lewis Carroll's "The Walrus and the Carpenter," and "the rest of the poem fell into place from there." Note the way her snaking white trails in between the words create an interesting pattern and slow down your reading experience.

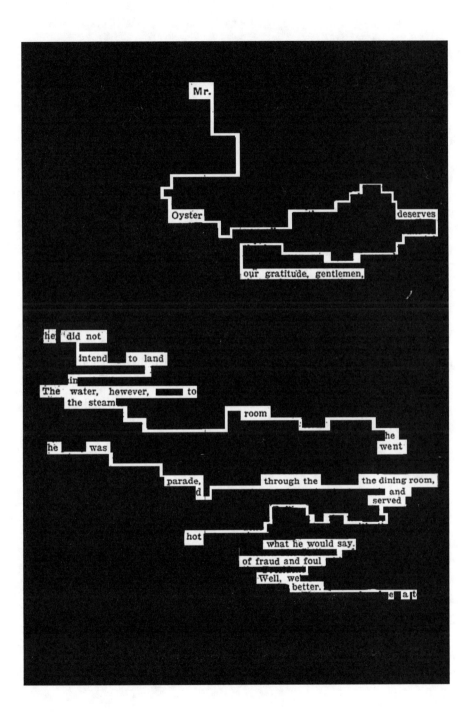

Mr.

Oyster deserves

our gratitude, gentlemen,

he did not

intend to land

in

The water, however, to
the steam

room

he
went

he was

parade, through the the dining room,
d and
served

hot what he would say.

of fraud and foul

Well, we
better. e a t

"TEETH" BY MARTY SMITH

Marty's poem doesn't completely transform the original text (the article was about dentistry), but the teeth marks (made with Photoshop on the computer) make it into something new and visually interesting. Marty is an IT worker from Washington, D.C., so it makes sense that he would incorporate a computer into the process of making his poem. This brings us to an interesting point: one need not limit oneself to a simple black marker to make blackout poems. Any tool, be it a pencil or a laptop, is on the table.

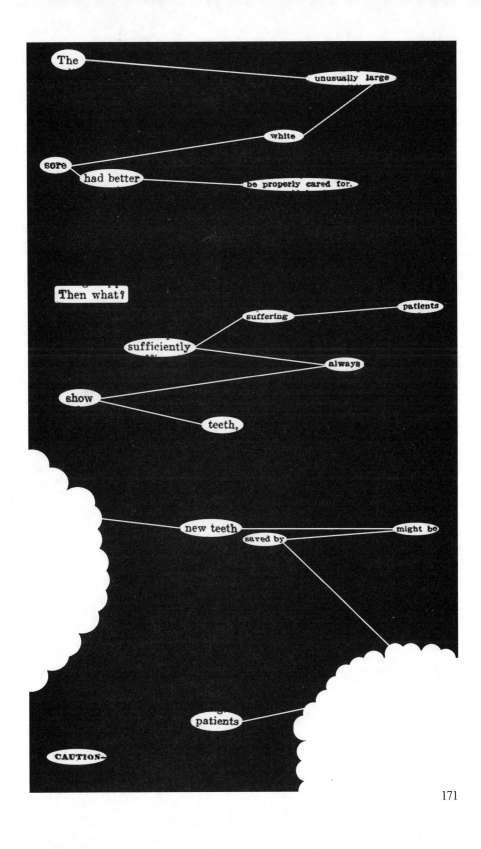

171

"ENIGMA" BY ERICA WESTCOTT

Erica is a histology technician from Virginia Beach, and after stumbling upon my blog, she thought she'd try her hand at a poem to pass the lunch hour at work. "It looked pretty easy," she said. "Just pick out a few words and string them together somehow, sort of like refrigerator magnet poetry. Wrong! I struggled for several days before coming up with something that sounded and looked just right." I love the restraint of Erica's poem, and the top-heavy black space. As I've blacked out in one of my own poems, "What sounds simple never comes across as dense with effort, but try it and see!"

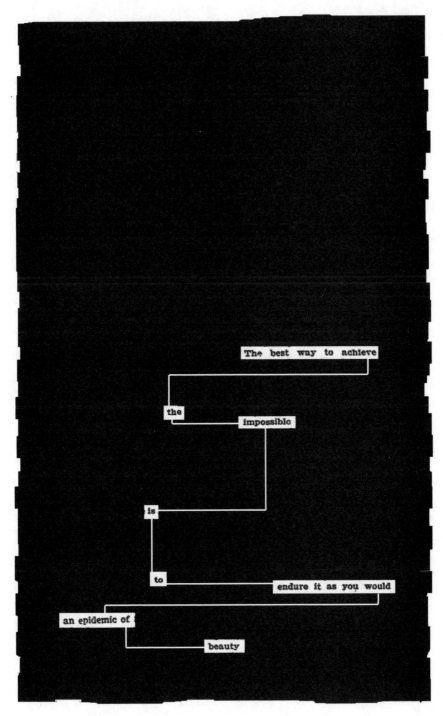

The best way to achieve

the

impossible

is

to

endure it as you would

an epidemic of

beauty

Acknowledgments

Big thanks to:

All the amazing fans, readers, and bloggers who linked to my Web site and spread the poems around the Internet. Without your support, I would've stopped making these things a long time ago. This book would not exist without you.

My wife, Meghan, who was the first person to read the poems and encourage me to do more, and who somehow found a narrative hiding within the two hundred or so poems I originally made for this book.

My editor, Amy Bendell, who saw a good thing and scooped it up.

And to the other good people at HarperCollins who have helped make the book happen: Lisa Sharkey, Amy Baker, Joseph Papa, and Erica Barmash.

Tom and Amy Feran, for their support and free legal advice.

My parents, who made me.

My family and my friends, many of whom might find themselves in this book. To paraphrase R. Crumb, "It's only marker on newsprint, folks!"

My teachers, past and present.

And finally, all the newspaper writers out there who ever struggled to meet a deadline and crank out copy day after day, who now find themselves in a dying industry. They are a national treasure. Go out and buy a newspaper to support them!

the

poet

places the

book

onto the scrap heap,

jeopardizing
his career.

but

w
a
i
t

snacks
and beverages
never fail

to

Fool the Fat Man

fooling him